BOTANICAL LINE DRAWING

Botanical

LINE DRAWING

200 STEP-BY-STEP FLOWERS, LEAVES, CACTI,
SUCCULENTS, AND OTHER ITEMS FOUND IN NATURE

PEGGY DEAN

WATSON·GUPTILL
CALIFORNIA | NEW YORK

Dedicated to my favorite
little wildflowers, Lucy and Billie

contents

Welcome to *Botanical Line Drawing!*

This is such a playful, sometimes delicate, and easier-than-you-probably-expect art form that doesn't require many materials, but does allow you to branch out and create something gorgeous by applying other types of art to your illustrations. Line drawing looks lovely as standalone piece but also works well when incorporating watercolor and hand lettering. Adding line drawings can really bring a piece to life.

This step-by-step book guides you through pages and pages of simple illustrated instruction, with five steps per illustration. You will see that each step adds onto the previous shape or detail, and in no time, you'll have produced your very own coveted line drawing!

I encourage you to pull out a sketchbook and practice these plants separately, then bring them together to showcase them as a lovely floral wreath, bouquet, wildflower field, succulent garden, and more. Options are limitless with this art form!

Botanical Catalog

Leaves

green ash

STEP 1

STEP 2

STEP 3

STEP 4

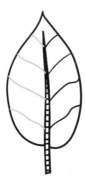

STEP 5

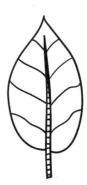

FINISHED!

draw it!

monkey grass

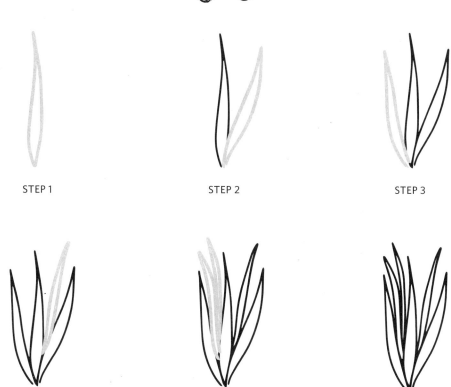

STEP 1

STEP 2

STEP 3

STEP 4

STEP 5

FINISHED!

draw it!

rowan

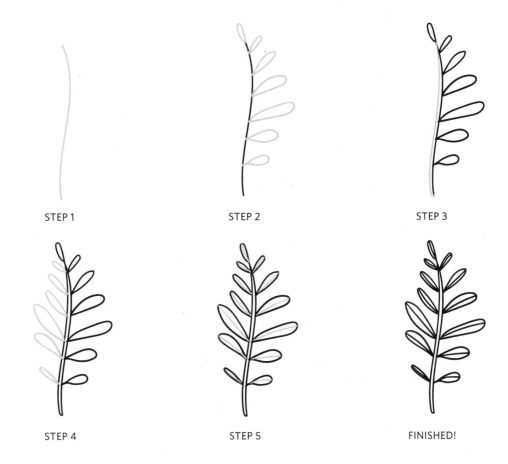

STEP 1 STEP 2 STEP 3

STEP 4 STEP 5 FINISHED!

draw it!

large-leaved lime

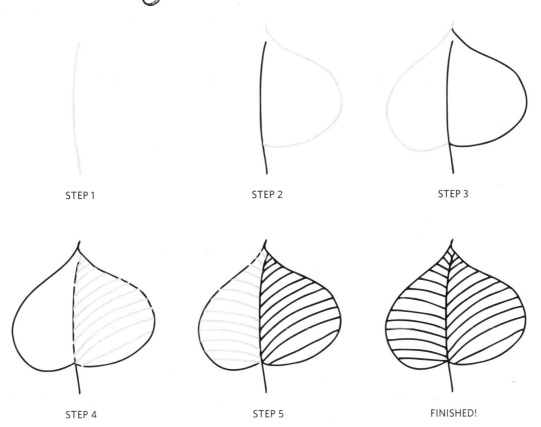

STEP 1

STEP 2

STEP 3

STEP 4

STEP 5

FINISHED!

draw it!

silverberry

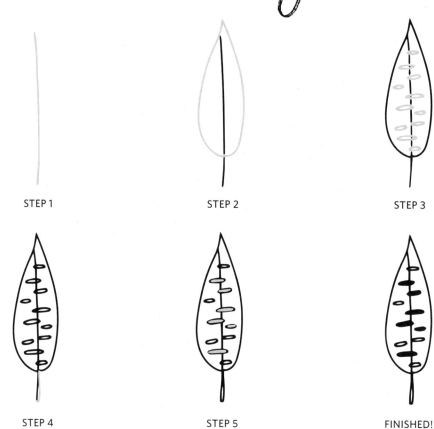

STEP 1

STEP 2

STEP 3

STEP 4

STEP 5

FINISHED!

draw it!

French pussy willow

STEP 1

STEP 2

STEP 3

STEP 4

STEP 5

FINISHED!

draw it!

catalpa

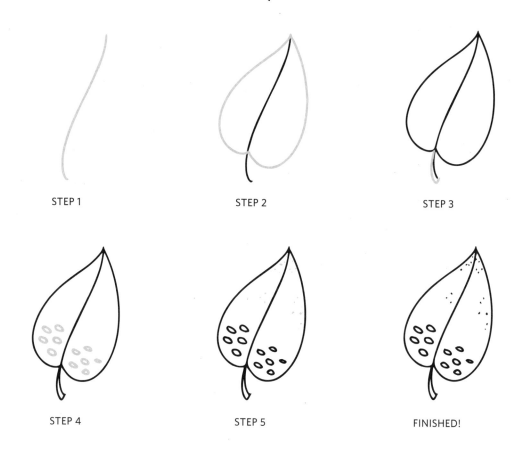

STEP 1 STEP 2 STEP 3

STEP 4 STEP 5 FINISHED!

draw it!

rauli

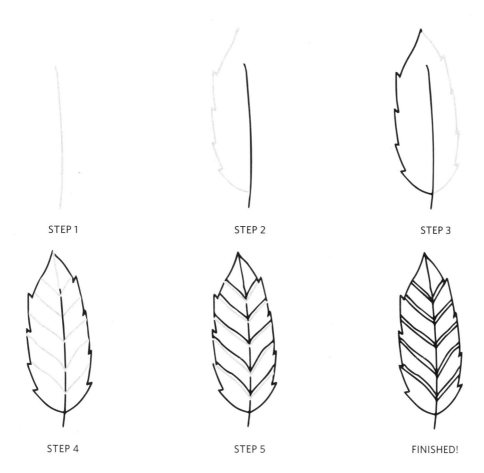

STEP 1

STEP 2

STEP 3

STEP 4

STEP 5

FINISHED!

draw it!

freckle face

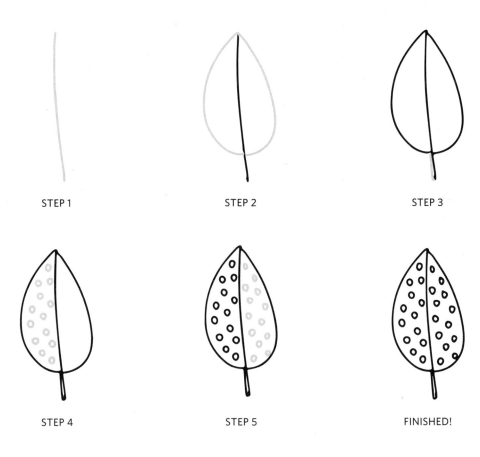

STEP 1 STEP 2 STEP 3

STEP 4 STEP 5 FINISHED!

draw it!

gingko

STEP 1

STEP 2

STEP 3

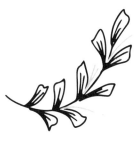

STEP 4

STEP 5

FINISHED!

draw it!

dogwood

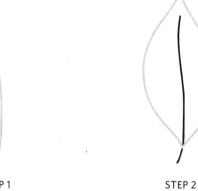

STEP 1 STEP 2 STEP 3

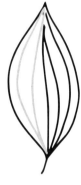 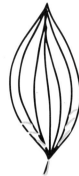 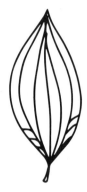

STEP 4 STEP 5 FINISHED!

draw it!

black locust

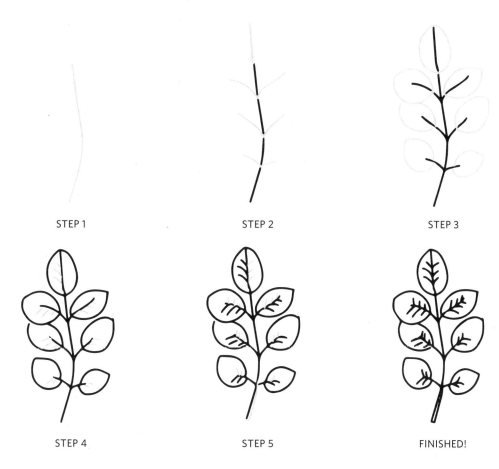

STEP 1

STEP 2

STEP 3

STEP 4

STEP 5

FINISHED!

draw it!

willow eucalyptus

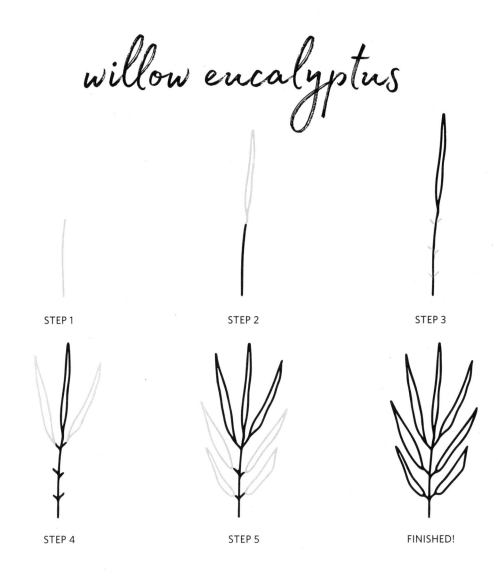

STEP 1

STEP 2

STEP 3

STEP 4

STEP 5

FINISHED!

draw it!

wild senna

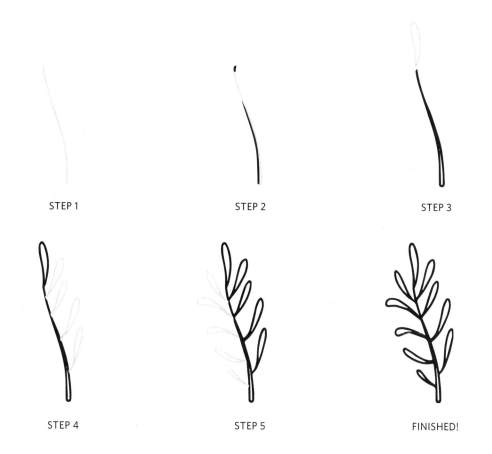

STEP 1 STEP 2 STEP 3

STEP 4 STEP 5 FINISHED!

draw it!

star jasmine

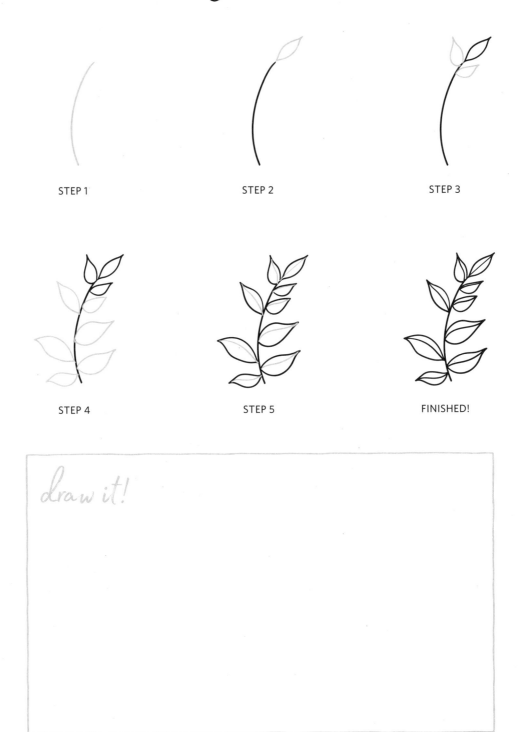

STEP 1

STEP 2

STEP 3

STEP 4

STEP 5

FINISHED!

draw it!

ash

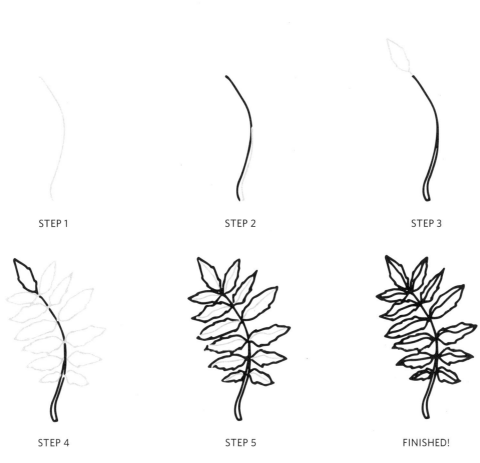

STEP 1

STEP 2

STEP 3

STEP 4

STEP 5

FINISHED!

draw it!

olive branch

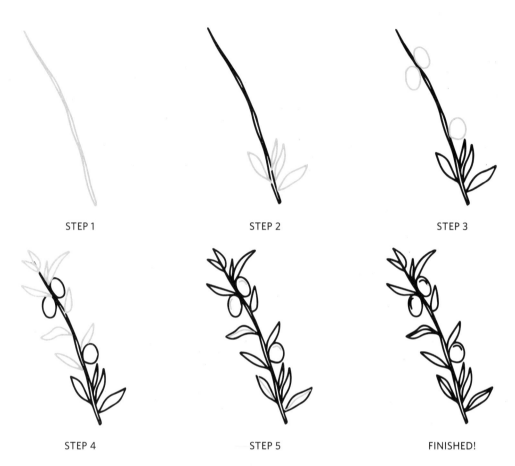

STEP 1

STEP 2

STEP 3

STEP 4

STEP 5

FINISHED!

draw it!

bamboo

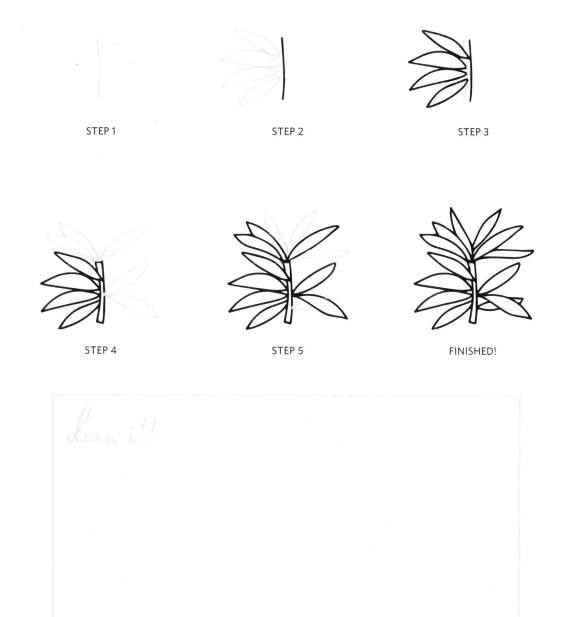

STEP 1

STEP 2

STEP 3

STEP 4

STEP 5

FINISHED!

draw it!

seedling

STEP 1

STEP 2

STEP 3

STEP 4

STEP 5

FINISHED!

draw it!

weeping willow

STEP 1

STEP 2

STEP 3

STEP 4

STEP 5

FINISHED!

draw it!

western red cedar

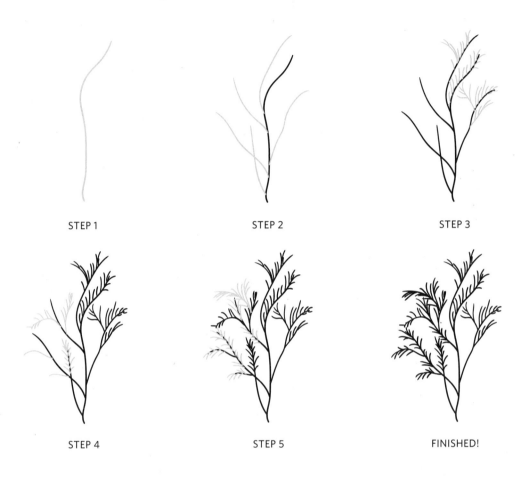

STEP 1

STEP 2

STEP 3

STEP 4

STEP 5

FINISHED!

draw it!

Japanese aralia

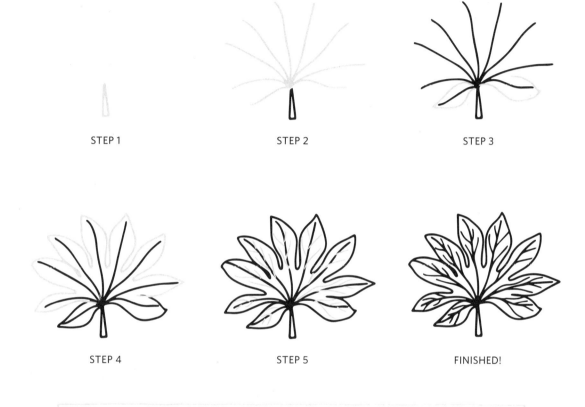

STEP 1

STEP 2

STEP 3

STEP 4

STEP 5

FINISHED!

draw it!

lima bean seedling

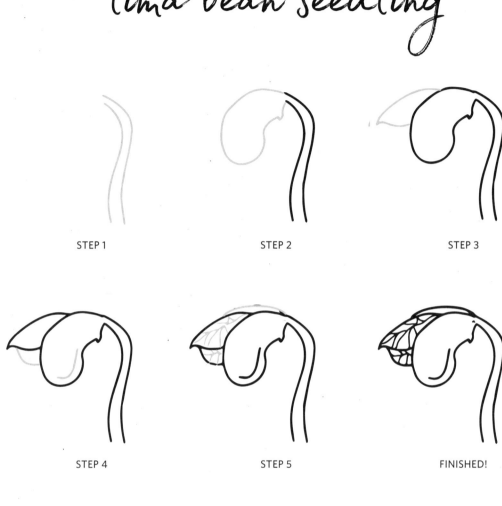

STEP 1 STEP 2 STEP 3

STEP 4 STEP 5 FINISHED!

draw it!

maidenhair fern

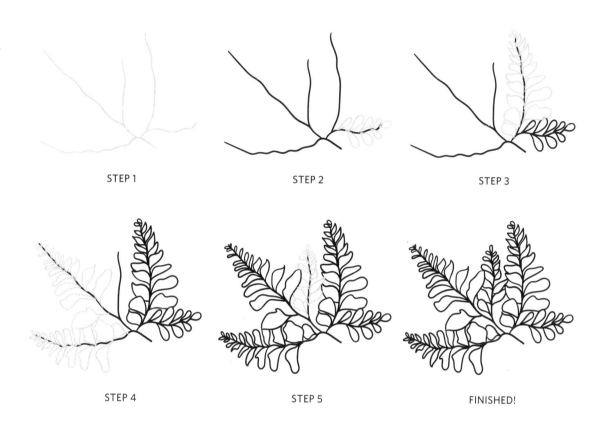

STEP 1 STEP 2 STEP 3

STEP 4 STEP 5 FINISHED!

draw it!

groundsel

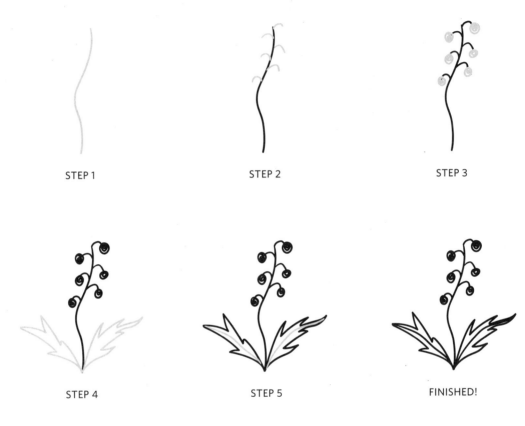

STEP 1 STEP 2 STEP 3

STEP 4 STEP 5 FINISHED!

draw it!

curly fern

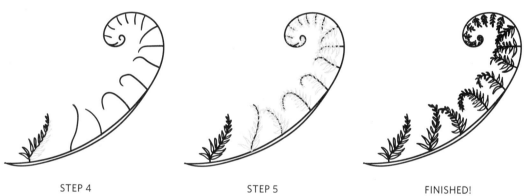

STEP 1 STEP 2 STEP 3

STEP 4 STEP 5 FINISHED!

draw it!

Boston fern

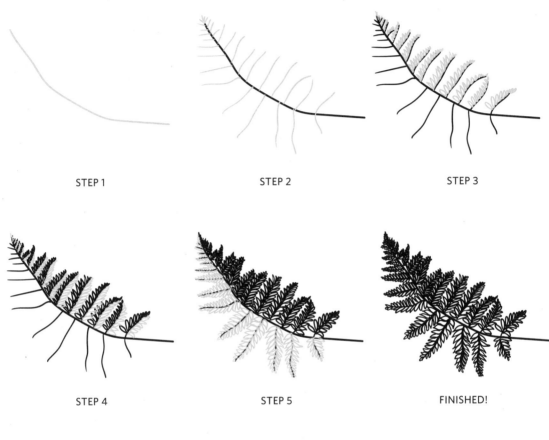

STEP 1 STEP 2 STEP 3

STEP 4 STEP 5 FINISHED!

draw it!

lobster claw

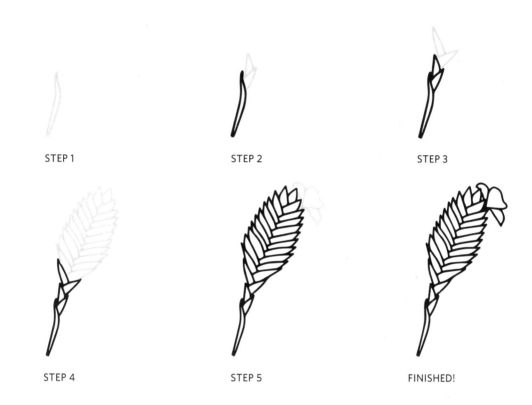

STEP 1

STEP 2

STEP 3

STEP 4

STEP 5

FINISHED!

draw it!

clover

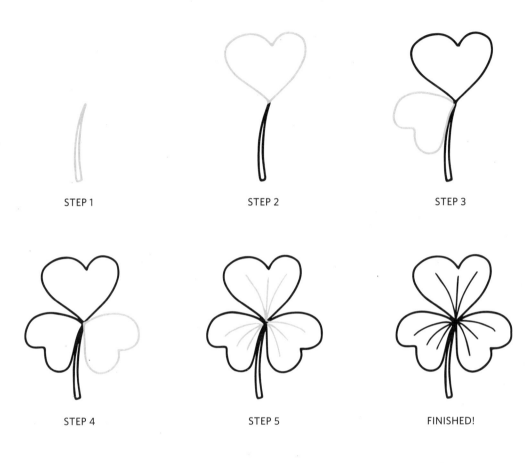

STEP 1 STEP 2 STEP 3

STEP 4 STEP 5 FINISHED!

draw it!

black poplar

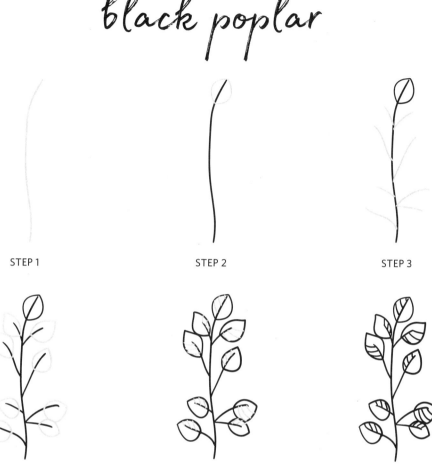

STEP 1

STEP 2

STEP 3

STEP 4

STEP 5

FINISHED!

draw it!

privet

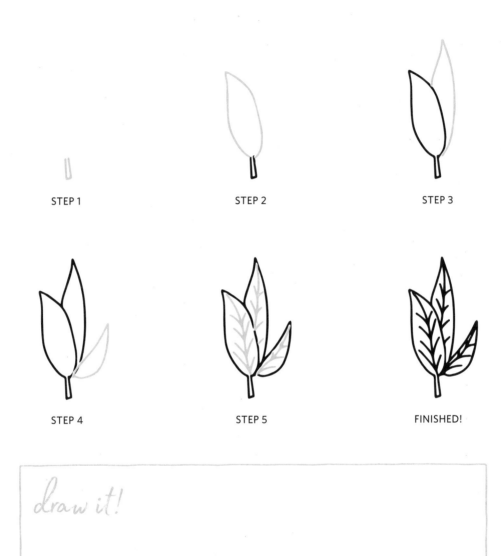

STEP 1

STEP 2

STEP 3

STEP 4

STEP 5

FINISHED!

draw it!

lady's thumb

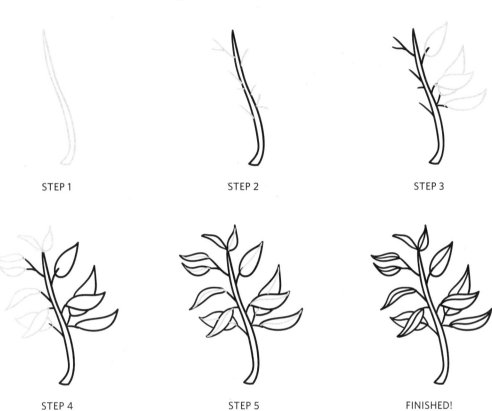

STEP 1

STEP 2

STEP 3

STEP 4

STEP 5

FINISHED!

draw it!

English holly

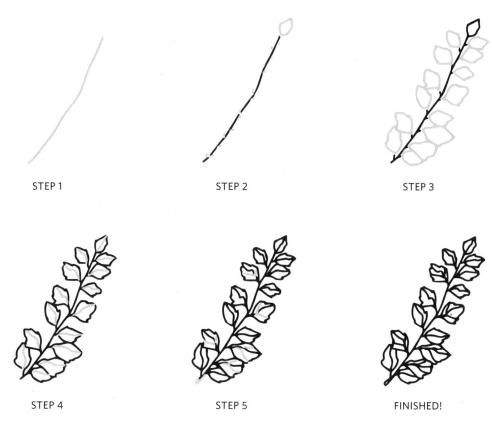

STEP 1 STEP 2 STEP 3

STEP 4 STEP 5 FINISHED!

draw it!

monstera

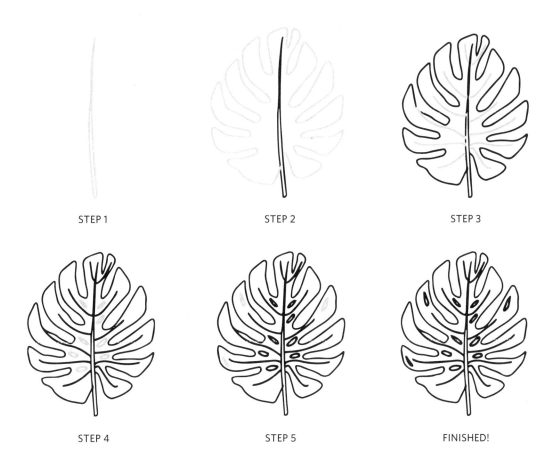

STEP 1

STEP 2

STEP 3

STEP 4

STEP 5

FINISHED!

draw it!

ruffled fan palm

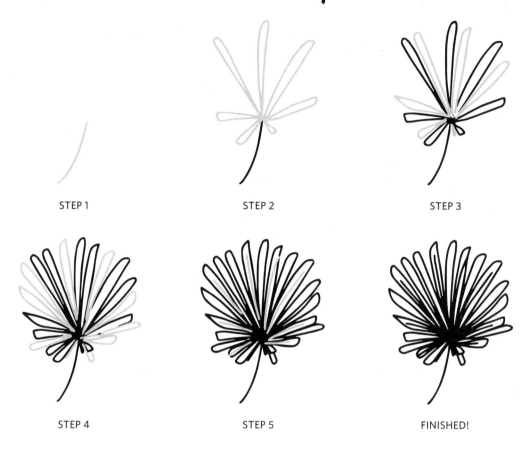

STEP 1

STEP 2

STEP 3

STEP 4

STEP 5

FINISHED!

draw it!

budding tree branch

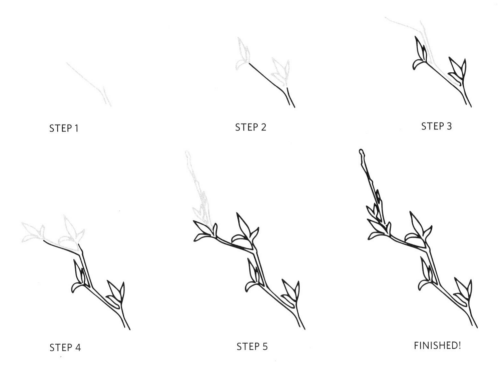

STEP 1 STEP 2 STEP 3

STEP 4 STEP 5 FINISHED!

draw it!

petticoat palm

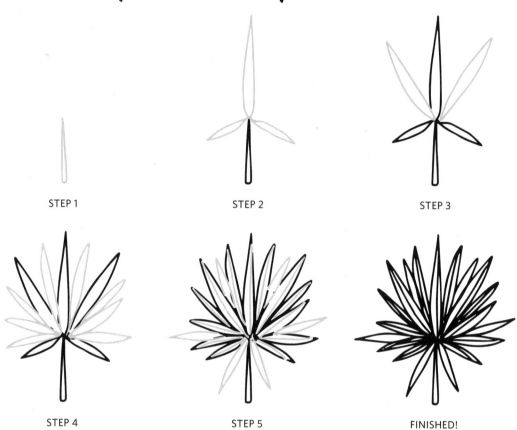

STEP 1

STEP 2

STEP 3

STEP 4

STEP 5

FINISHED!

draw it!

fancy leaf caladium

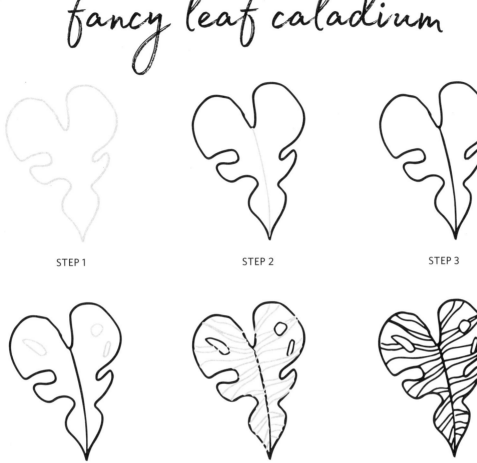

STEP 1

STEP 2

STEP 3

STEP 4

STEP 5

FINISHED!

draw it!

redwood

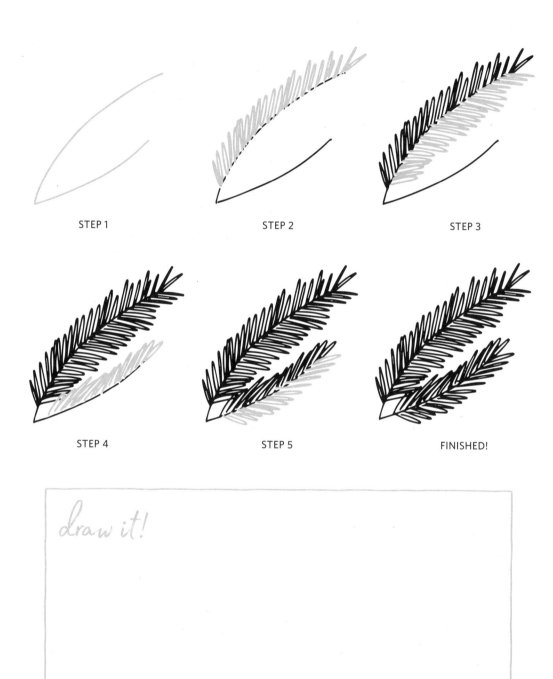

STEP 1

STEP 2

STEP 3

STEP 4

STEP 5

FINISHED!

draw it!

areca palm

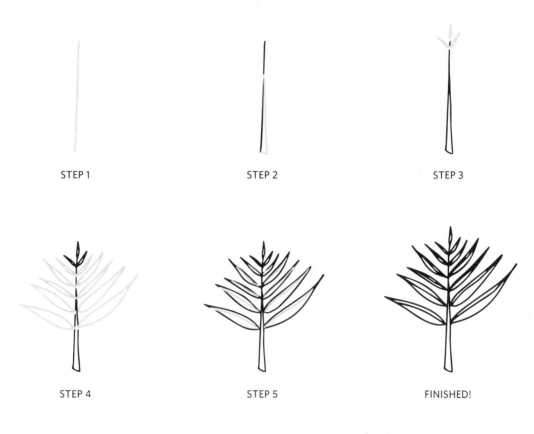

STEP 1

STEP 2

STEP 3

STEP 4

STEP 5

FINISHED!

draw it!

American hornbeam

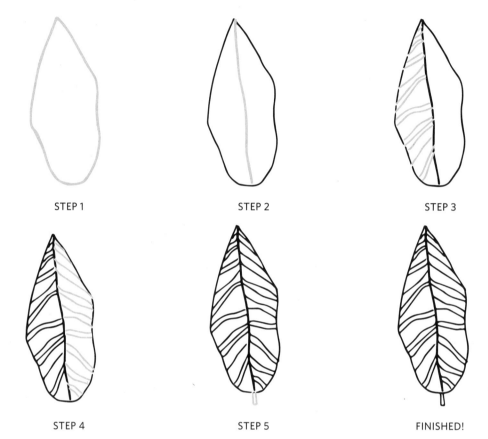

STEP 1

STEP 2

STEP 3

STEP 4

STEP 5

FINISHED!

draw it!

sword fern

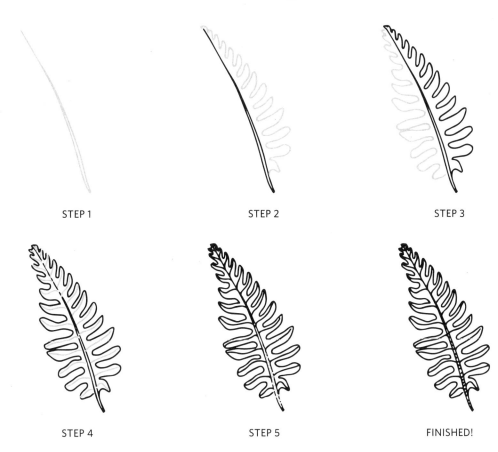

STEP 1

STEP 2

STEP 3

STEP 4

STEP 5

FINISHED!

draw it!

guava

STEP 1

STEP 2

STEP 3

STEP 4

STEP 5

FINISHED!

draw it!

oak

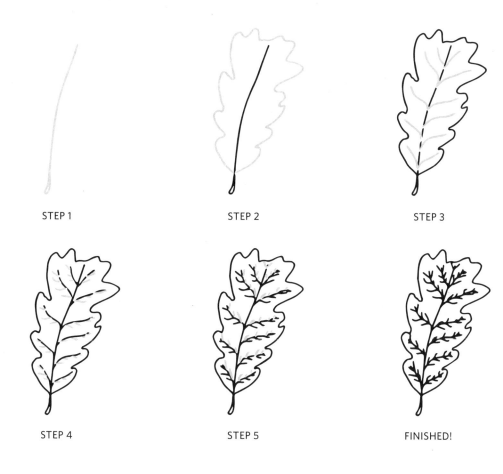

STEP 1

STEP 2

STEP 3

STEP 4

STEP 5

FINISHED!

draw it!

maple

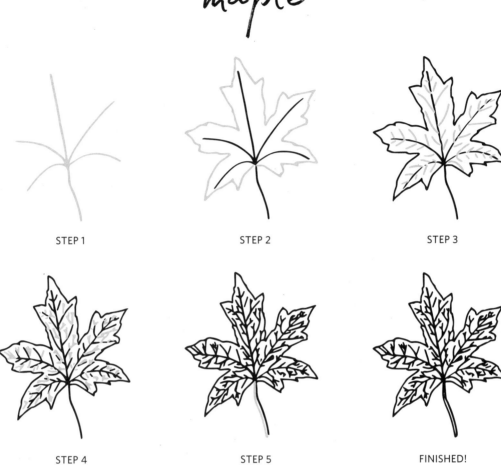

STEP 1

STEP 2

STEP 3

STEP 4

STEP 5

FINISHED!

draw it!

elm

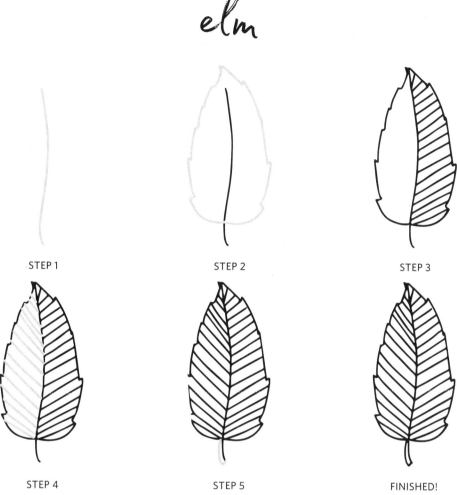

STEP 1

STEP 2

STEP 3

STEP 4

STEP 5

FINISHED!

draw it!

leatherleaf mahonia

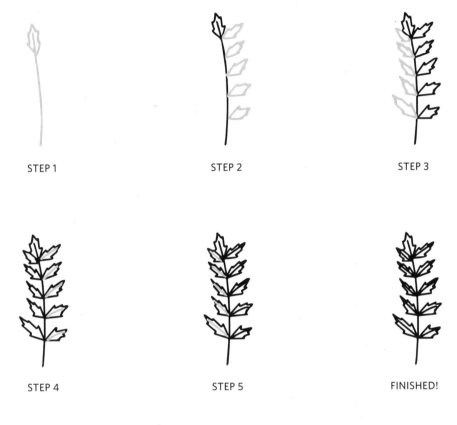

STEP 1

STEP 2

STEP 3

STEP 4

STEP 5

FINISHED!

draw it!

palm frond

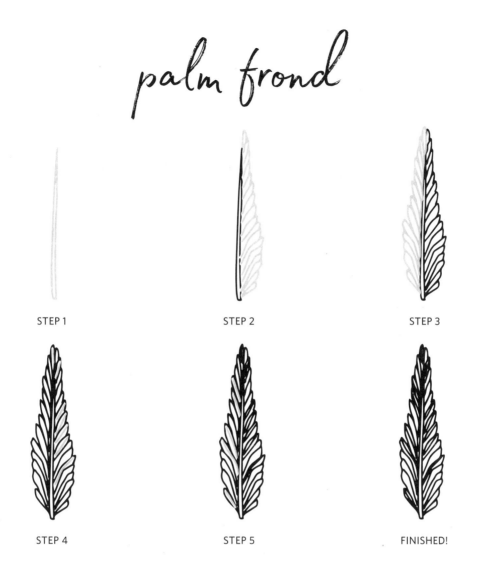

STEP 1

STEP 2

STEP 3

STEP 4

STEP 5

FINISHED!

draw it!

pignut hickory

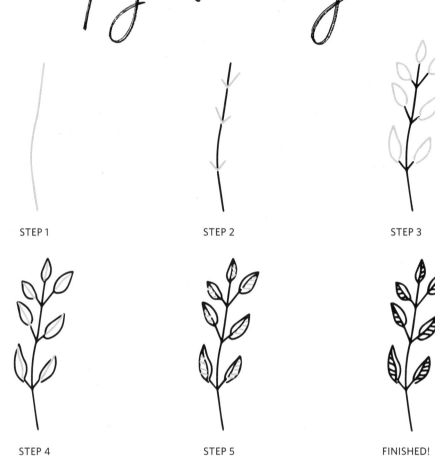

STEP 1

STEP 2

STEP 3

STEP 4

STEP 5

FINISHED!

draw it!

cabbage

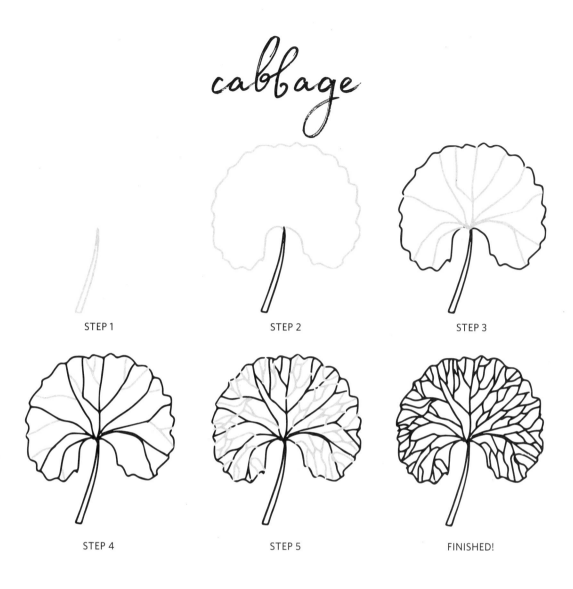

STEP 1

STEP 2

STEP 3

STEP 4

STEP 5

FINISHED!

draw it!

rattlebush

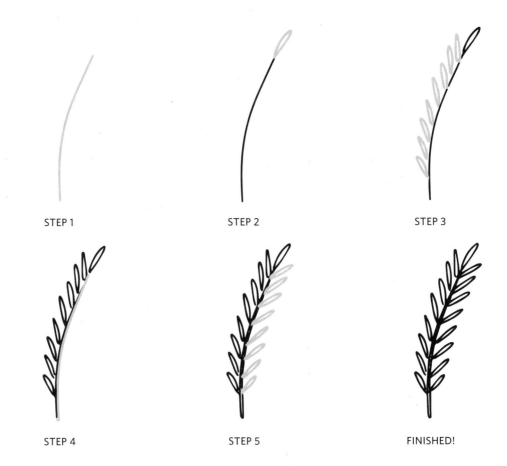

STEP 1

STEP 2

STEP 3

STEP 4

STEP 5

FINISHED!

draw it!

honeysuckle

STEP 1

STEP 2

STEP 3

STEP 4

STEP 5

FINISHED!

draw it!

honey locust

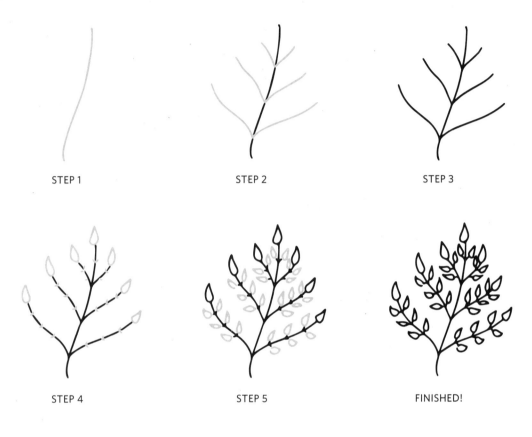

STEP 1

STEP 2

STEP 3

STEP 4

STEP 5

FINISHED!

draw it!

Persian shield

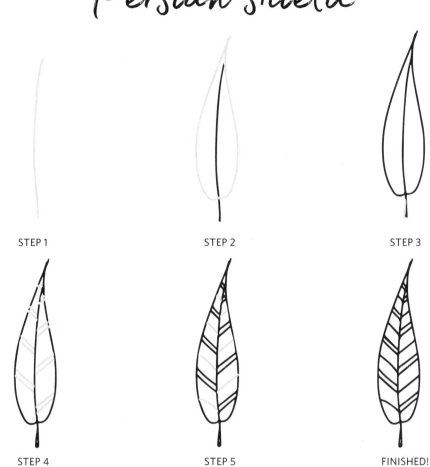

STEP 1

STEP 2

STEP 3

STEP 4

STEP 5

FINISHED!

draw it!

button fern

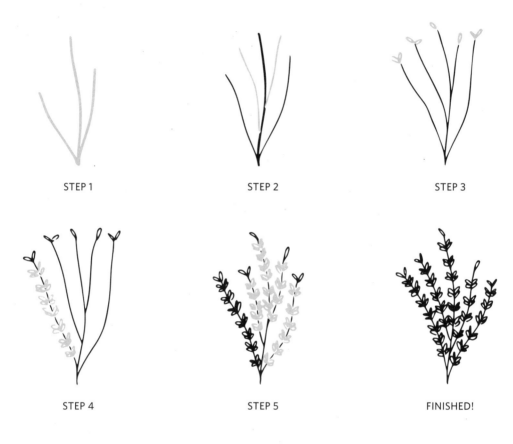

STEP 1 STEP 2 STEP 3

STEP 4 STEP 5 FINISHED!

draw it!

weigela

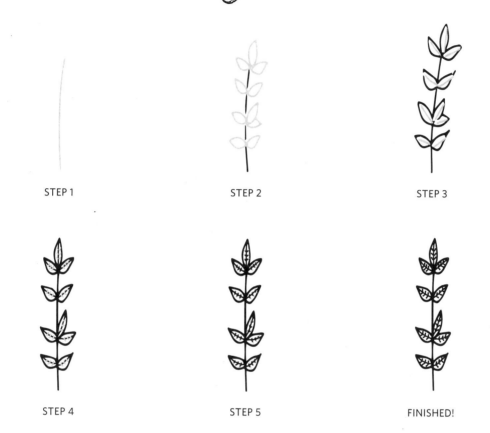

STEP 1

STEP 2

STEP 3

STEP 4

STEP 5

FINISHED!

draw it!

cotton

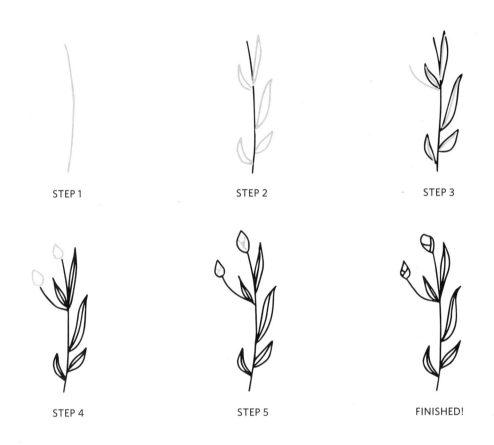

STEP 1 STEP 2 STEP 3

STEP 4 STEP 5 FINISHED!

draw it!

Old World forked fern

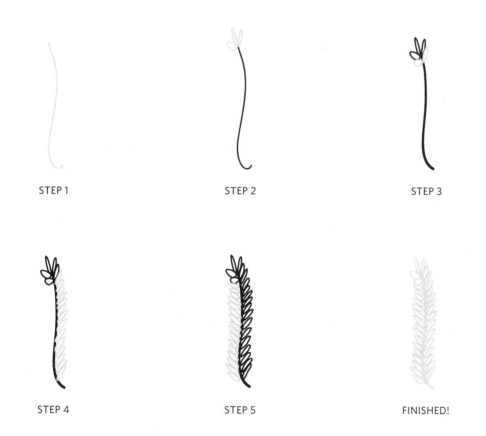

STEP 1

STEP 2

STEP 3

STEP 4

STEP 5

FINISHED!

draw it!

olive

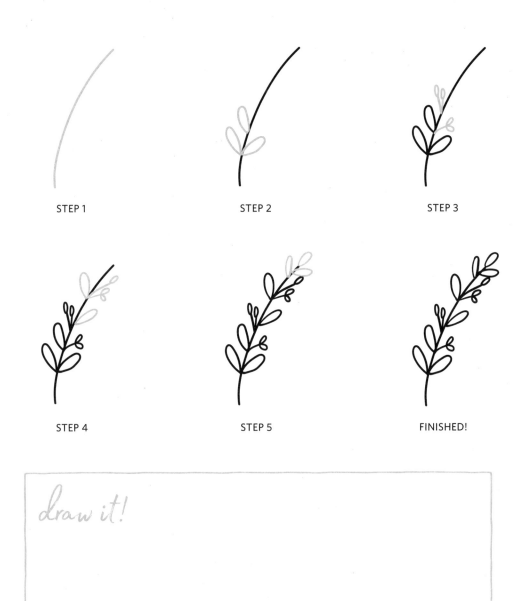

STEP 1　　　　STEP 2　　　　STEP 3

STEP 4　　　　STEP 5　　　　FINISHED!

draw it!

sprout

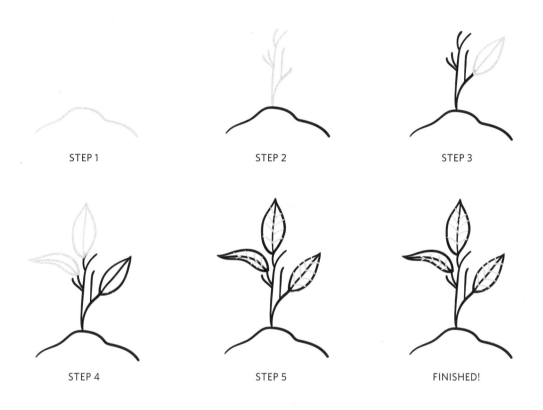

STEP 1 STEP 2 STEP 3

STEP 4 STEP 5 FINISHED!

draw it!

delta fern

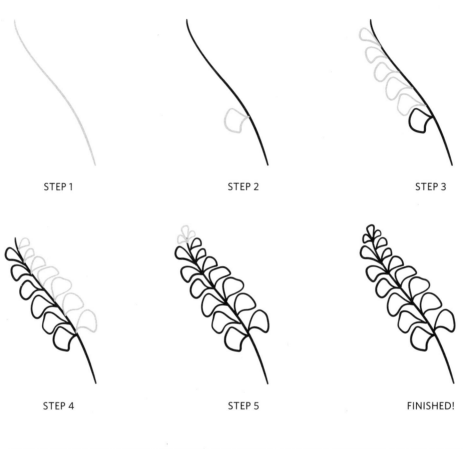

STEP 1

STEP 2

STEP 3

STEP 4

STEP 5

FINISHED!

draw it!

cattail

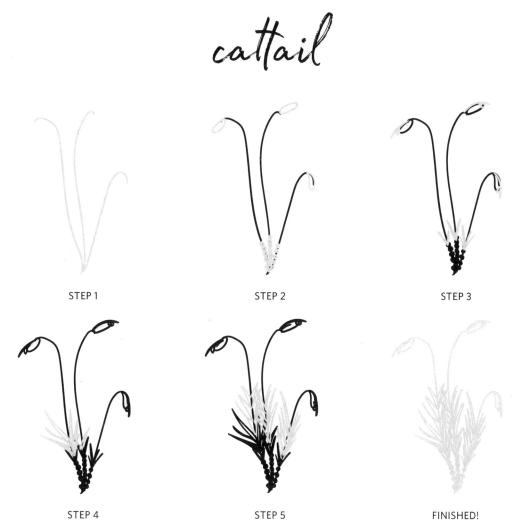

STEP 1

STEP 2

STEP 3

STEP 4

STEP 5

FINISHED!

draw it!

Flowers

desert marigold

STEP 1

STEP 2

STEP 3

STEP 4

STEP 5

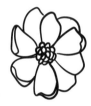

FINISHED!

draw it!

Kankakee mallow

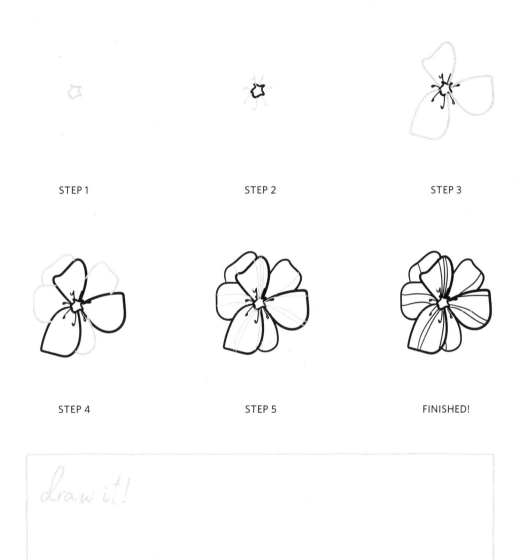

STEP 1

STEP 2

STEP 3

STEP 4

STEP 5

FINISHED!

draw it!

flower bud

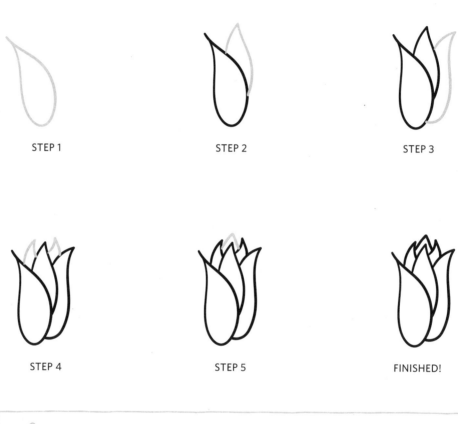

STEP 1 STEP 2 STEP 3

STEP 4 STEP 5 FINISHED!

draw it!

China aster

STEP 1

STEP 2

STEP 3

STEP 4

STEP 5

FINISHED!

draw it!

rose

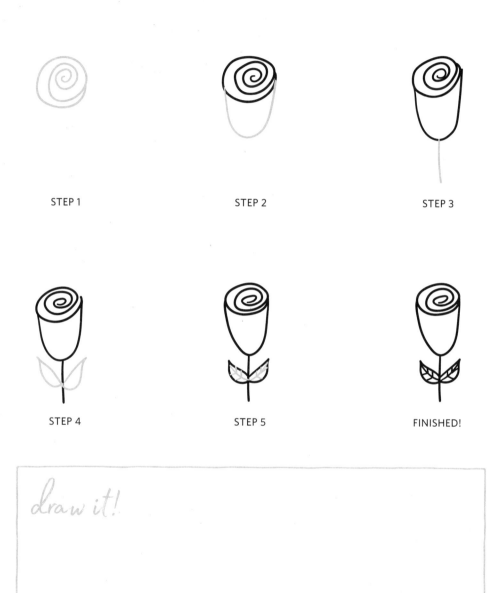

STEP 1

STEP 2

STEP 3

STEP 4

STEP 5

FINISHED!

draw it!

lisianthus

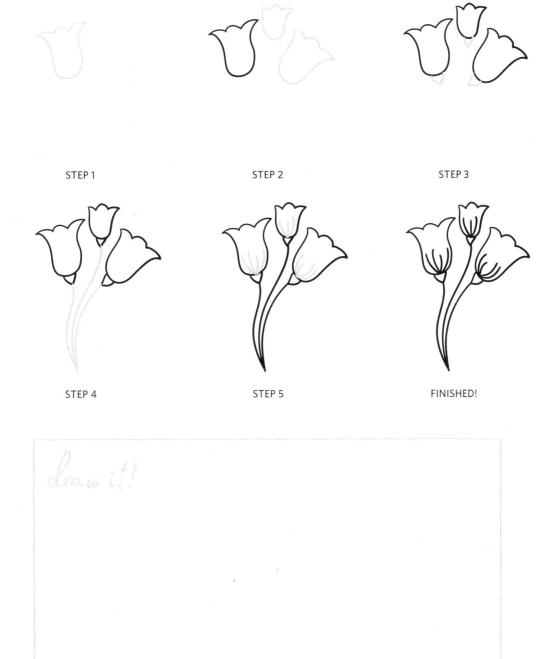

STEP 1

STEP 2

STEP 3

STEP 4

STEP 5

FINISHED!

draw it!

morning glory

STEP 1

STEP 2

STEP 3

STEP 4

STEP 5

FINISHED!

draw it!

English rose

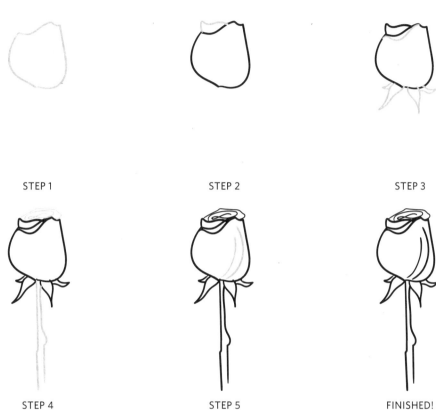

STEP 1 STEP 2 STEP 3

STEP 4 STEP 5 FINISHED!

draw it!

plumed cockscomb

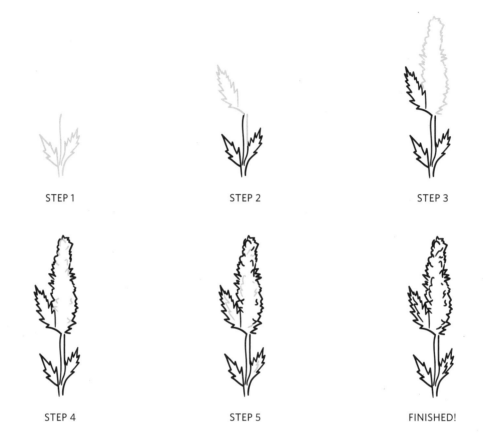

STEP 1

STEP 2

STEP 3

STEP 4

STEP 5

FINISHED!

draw it!

chicory

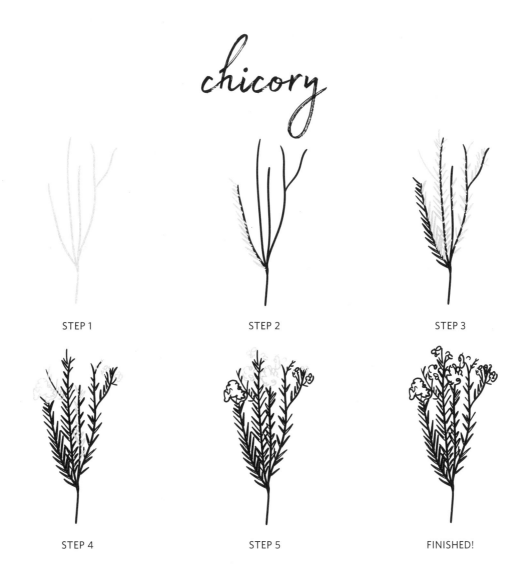

STEP 1

STEP 2

STEP 3

STEP 4

STEP 5

FINISHED!

draw it!

ranunculus

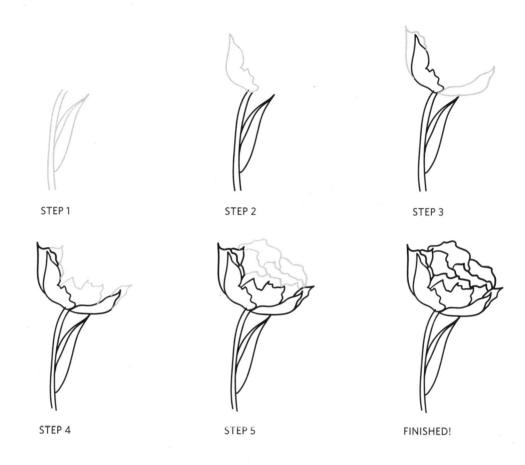

STEP 1

STEP 2

STEP 3

STEP 4

STEP 5

FINISHED!

draw it!

larkspur

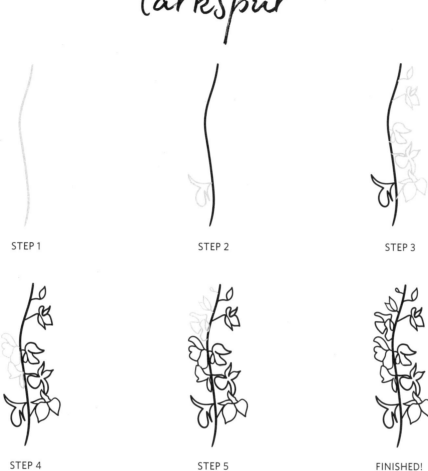

STEP 1 STEP 2 STEP 3

STEP 4 STEP 5 FINISHED!

draw it!

foxglove

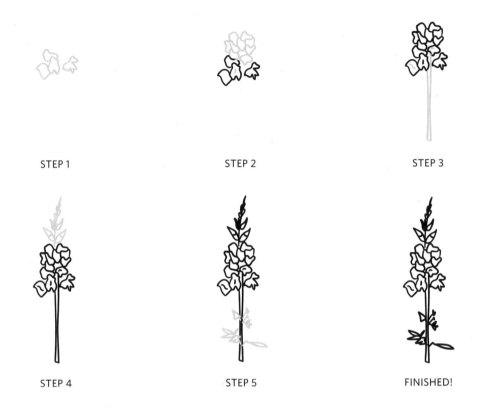

STEP 1

STEP 2

STEP 3

STEP 4

STEP 5

FINISHED!

draw it!

cosmos

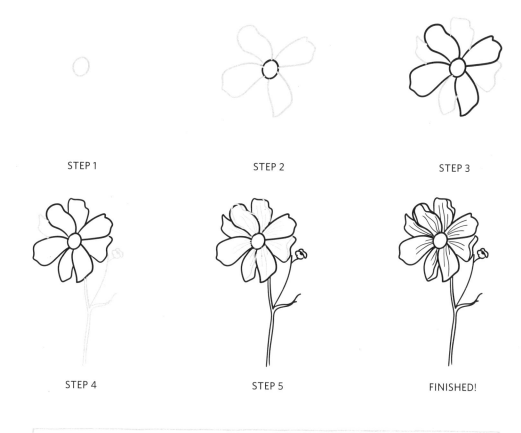

STEP 1

STEP 2

STEP 3

STEP 4

STEP 5

FINISHED!

draw it!

tulip

STEP 1

STEP 2

STEP 3

STEP 4

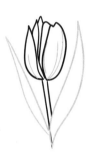

STEP 5

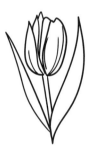

FINISHED!

draw it!

snake's head fritillary

STEP 1

STEP 2

STEP 3

STEP 4

STEP 5

FINISHED!

draw it!

hydrangea

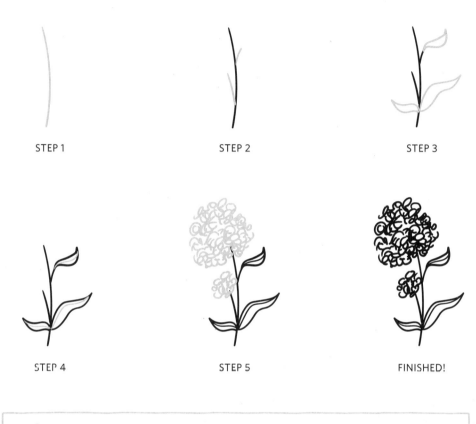

STEP 1

STEP 2

STEP 3

STEP 4

STEP 5

FINISHED!

draw it!

kangaroo paw

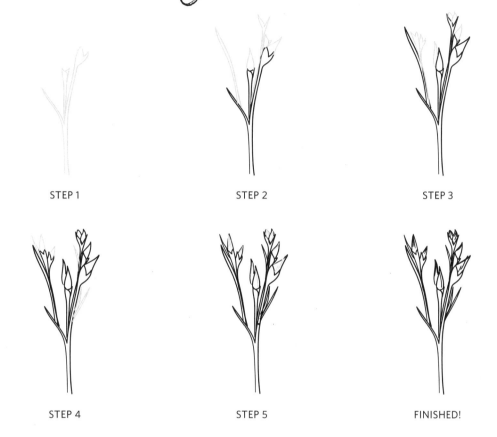

STEP 1

STEP 2

STEP 3

STEP 4

STEP 5

FINISHED!

draw it!

coreopsis

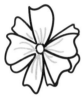

STEP 1

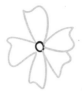

STEP 2

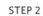

STEP 3

STEP 4

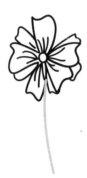

STEP 5

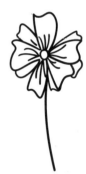

FINISHED!

draw it!

daffodil

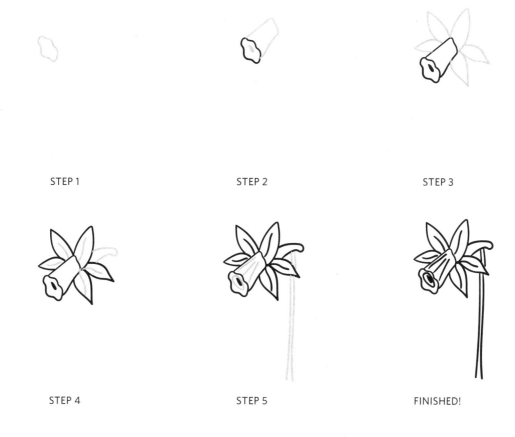

STEP 1 STEP 2 STEP 3

STEP 4 STEP 5 FINISHED!

draw it!

buttercup

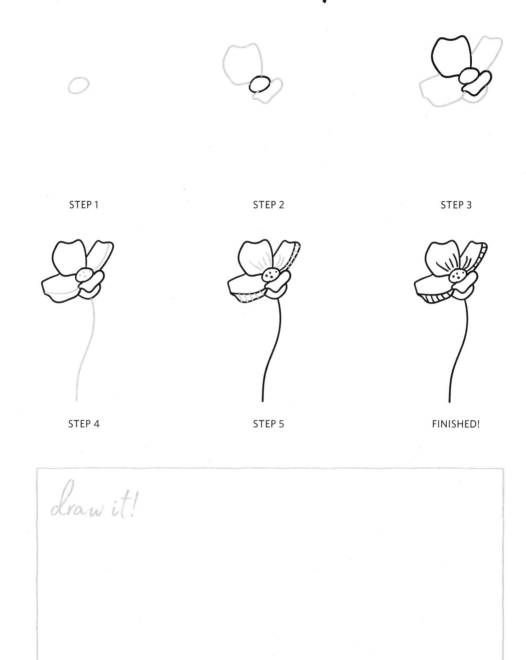

STEP 1

STEP 2

STEP 3

STEP 4

STEP 5

FINISHED!

draw it!

candle bush

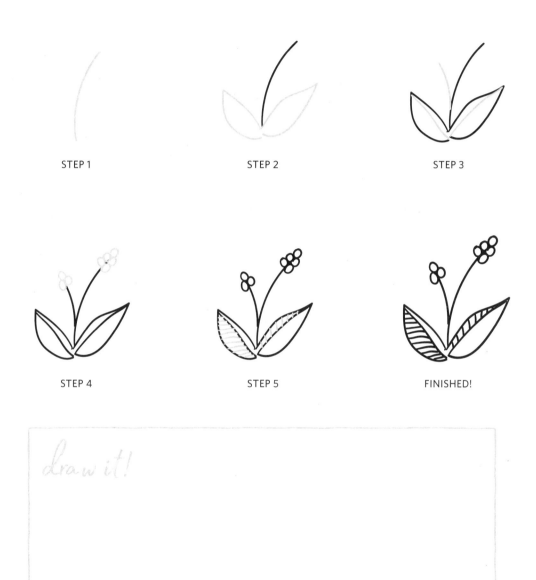

STEP 1

STEP 2

STEP 3

STEP 4

STEP 5

FINISHED!

draw it!

dianthus

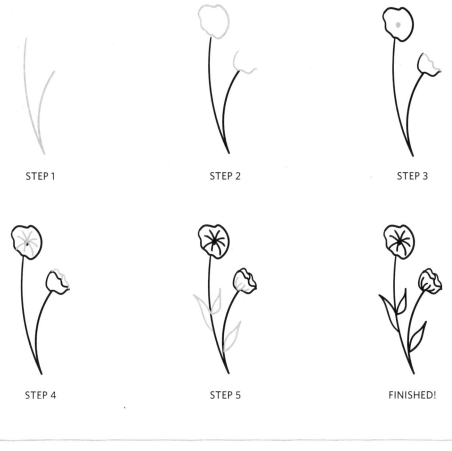

STEP 1

STEP 2

STEP 3

STEP 4

STEP 5

FINISHED!

draw it!

begonia

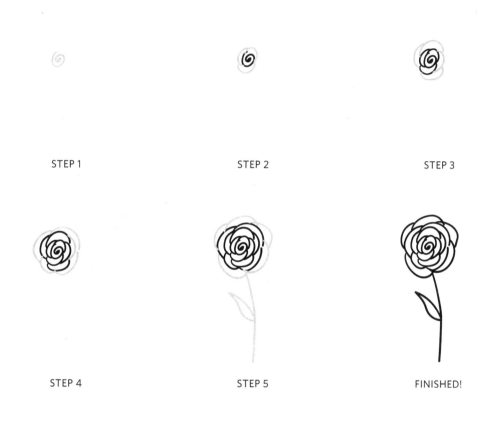

STEP 1

STEP 2

STEP 3

STEP 4

STEP 5

FINISHED!

draw it!

black-eyed Susan

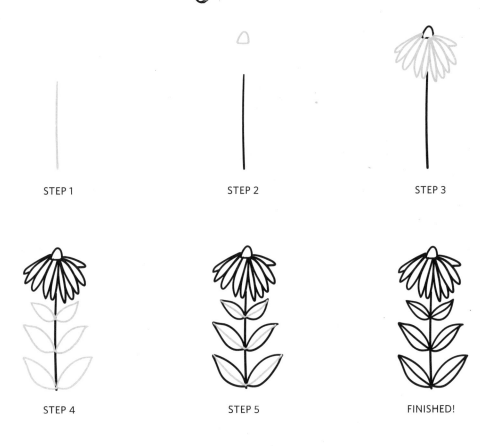

STEP 1 STEP 2 STEP 3

STEP 4 STEP 5 FINISHED!

draw it!

tulip

STEP 1

STEP 2

STEP 3

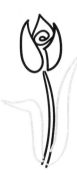

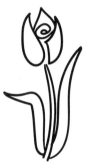

STEP 4

STEP 5

FINISHED!

draw it!

violet

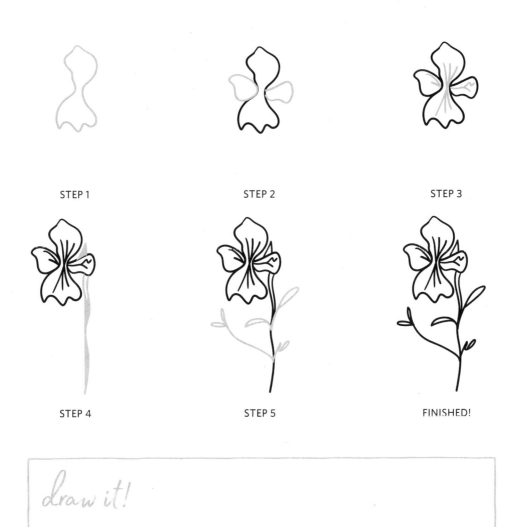

STEP 1

STEP 2

STEP 3

STEP 4

STEP 5

FINISHED!

draw it!

primrose

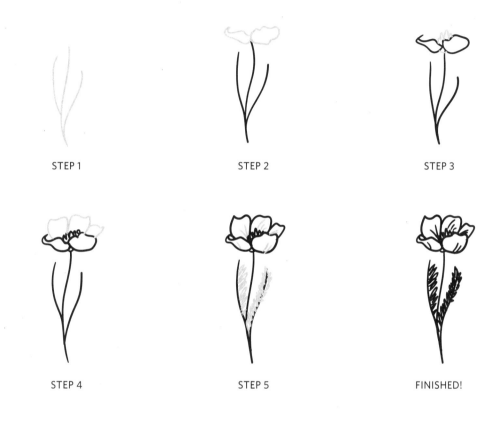

STEP 1

STEP 2

STEP 3

STEP 4

STEP 5

FINISHED!

draw it!

daisy

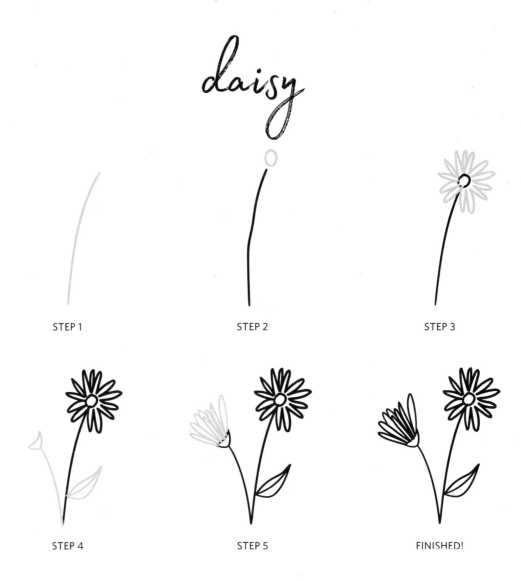

STEP 1 STEP 2 STEP 3

STEP 4 STEP 5 FINISHED!

draw it!

lavender

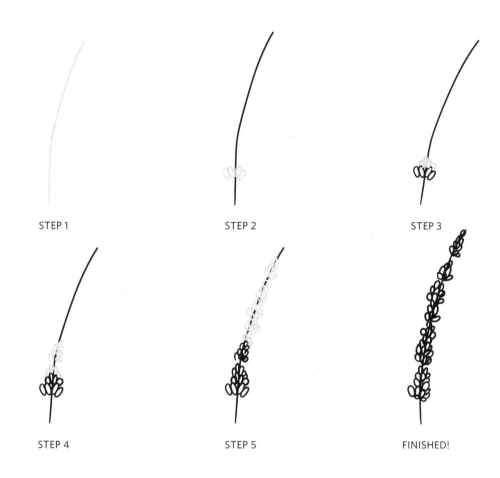

STEP 1

STEP 2

STEP 3

STEP 4

STEP 5

FINISHED!

draw it!

tatarian aster

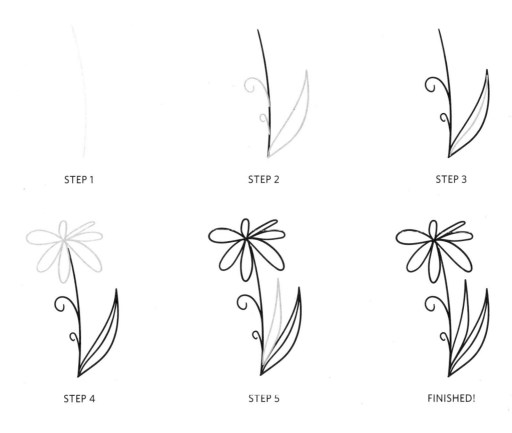

STEP 1 STEP 2 STEP 3

STEP 4 STEP 5 FINISHED!

draw it!

moss rose

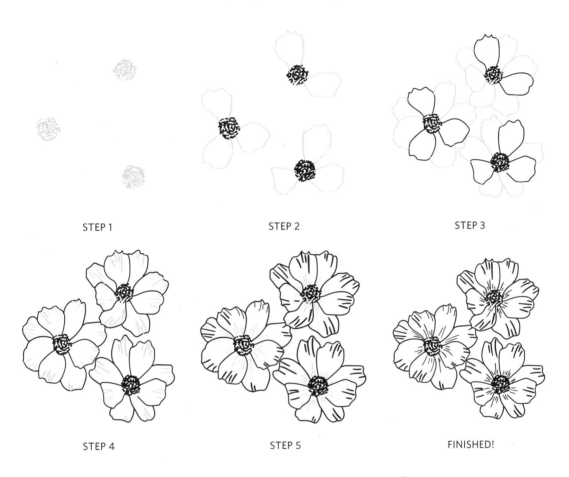

STEP 1

STEP 2

STEP 3

STEP 4

STEP 5

FINISHED!

draw it!

hellebore

STEP 1

STEP 2

STEP 3

STEP 4

STEP 5

FINISHED!

draw it!

hydrangea

STEP 1 STEP 2 STEP 3

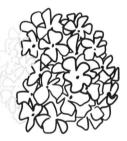

STEP 4 STEP 5 FINISHED!

draw it!

carnation

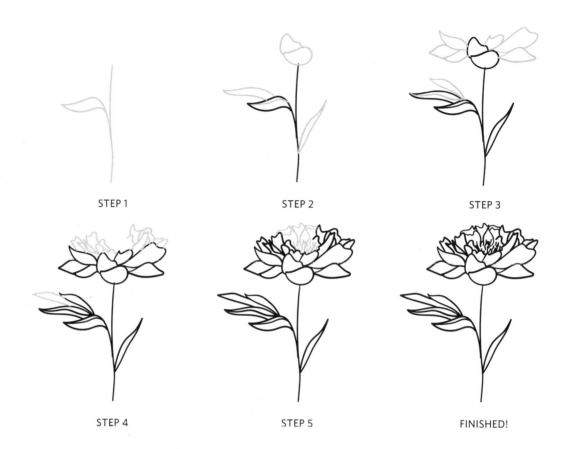

STEP 1

STEP 2

STEP 3

STEP 4

STEP 5

FINISHED!

draw it!

cabbage rose

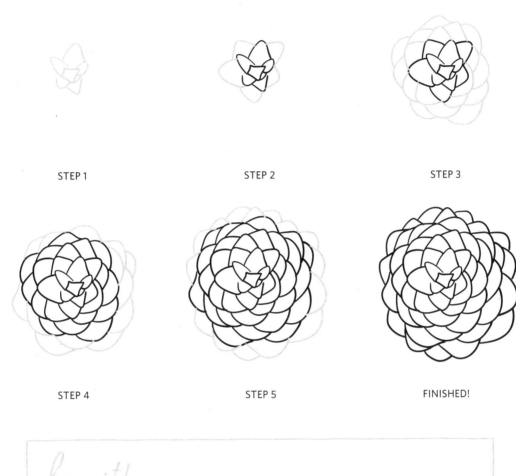

STEP 1

STEP 2

STEP 3

STEP 4

STEP 5

FINISHED!

draw it!

double aquilegia

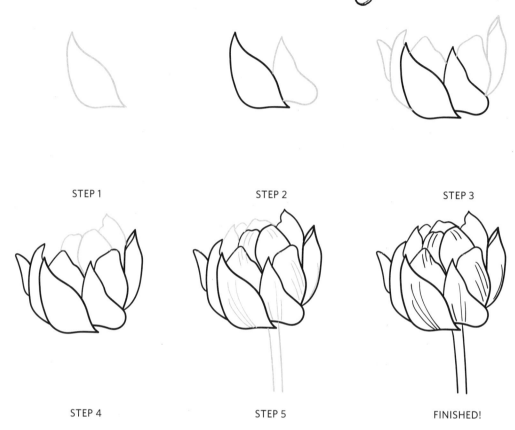

STEP 1 STEP 2 STEP 3

STEP 4 STEP 5 FINISHED!

draw it!

chamomile

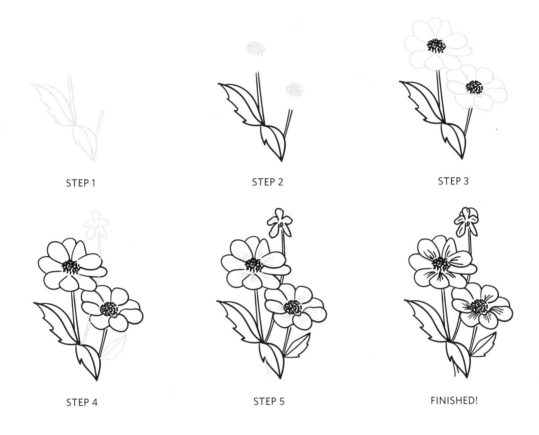

STEP 1

STEP 2

STEP 3

STEP 4

STEP 5

FINISHED!

draw it!

freesia

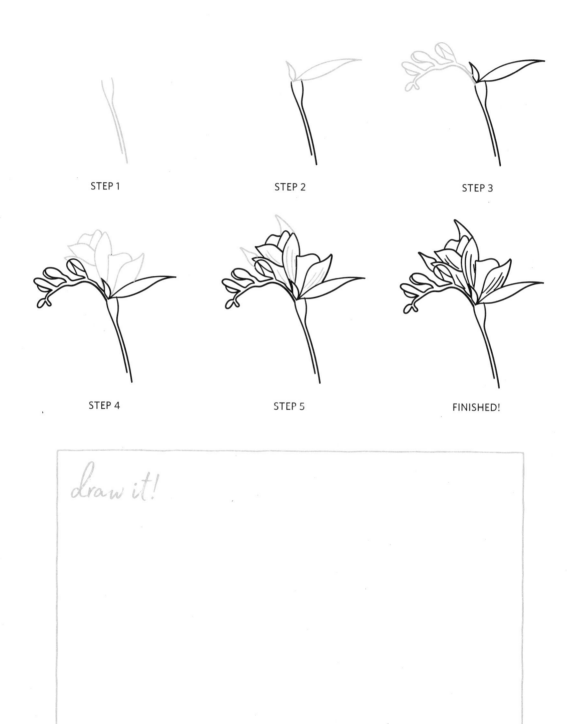

STEP 1

STEP 2

STEP 3

STEP 4

STEP 5

FINISHED!

draw it!

pompom dahlia

STEP 1 STEP 2 STEP 3

STEP 4 STEP 5 FINISHED!

draw it!

field scabious

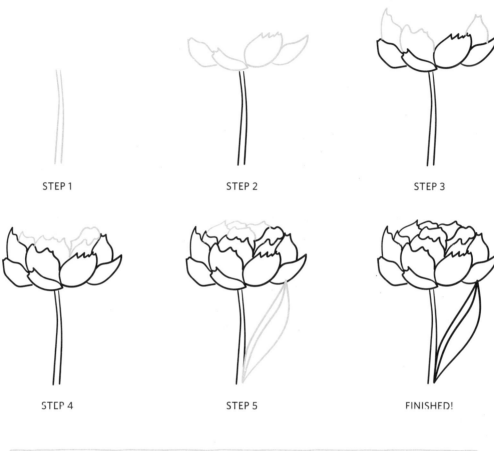

STEP 1 STEP 2 STEP 3

STEP 4 STEP 5 FINISHED!

draw it!

English rose

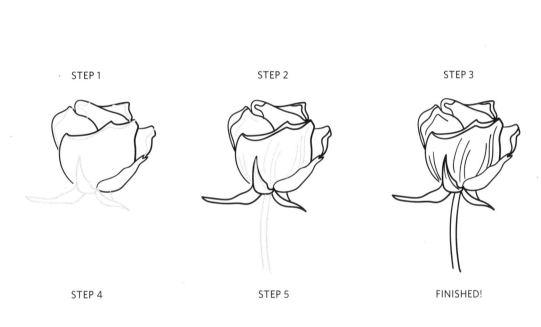

STEP 1

STEP 2

STEP 3

STEP 4

STEP 5

FINISHED!

draw it!

pincushion protea

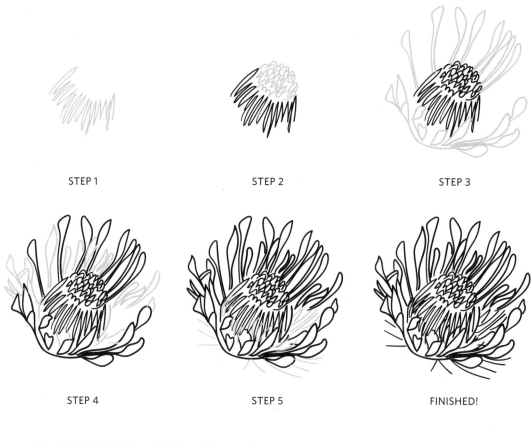

STEP 1

STEP 2

STEP 3

STEP 4

STEP 5

FINISHED!

draw it!

sunflower

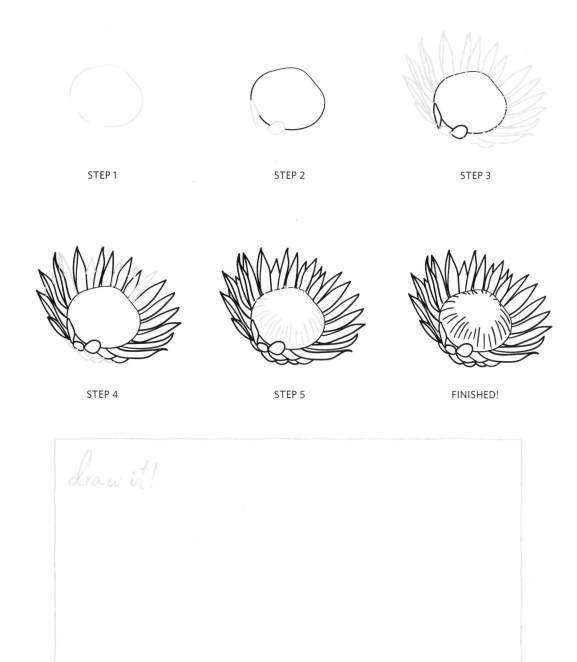

STEP 1

STEP 2

STEP 3

STEP 4

STEP 5

FINISHED!

draw it!

fuschia

STEP 1 STEP 2 STEP 3

STEP 4 STEP 5 FINISHED!

draw it!

yucca

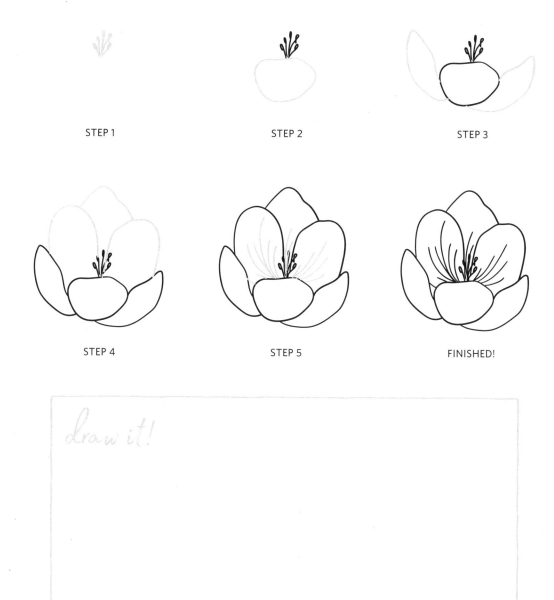

STEP 1

STEP 2

STEP 3

STEP 4

STEP 5

FINISHED!

draw it!

queen of the night

STEP 1 STEP 2 STEP 3

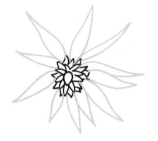

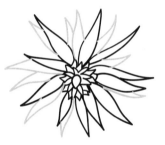

STEP 4 STEP 5 FINISHED!

draw it!

marigold

STEP 1

STEP 2

STEP 3

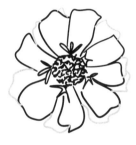

STEP 4

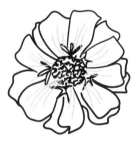

STEP 5

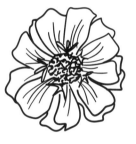

FINISHED!

draw it!

calla lily

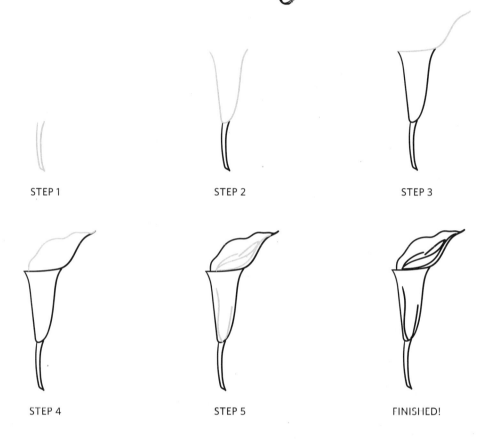

STEP 1

STEP 2

STEP 3

STEP 4

STEP 5

FINISHED!

draw it!

forget-me-not

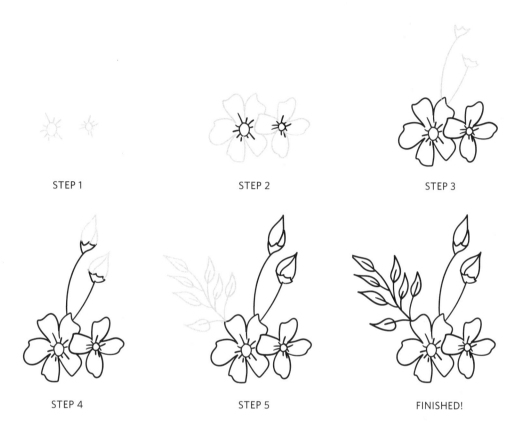

STEP 1

STEP 2

STEP 3

STEP 4

STEP 5

FINISHED!

draw it!

old garden rose

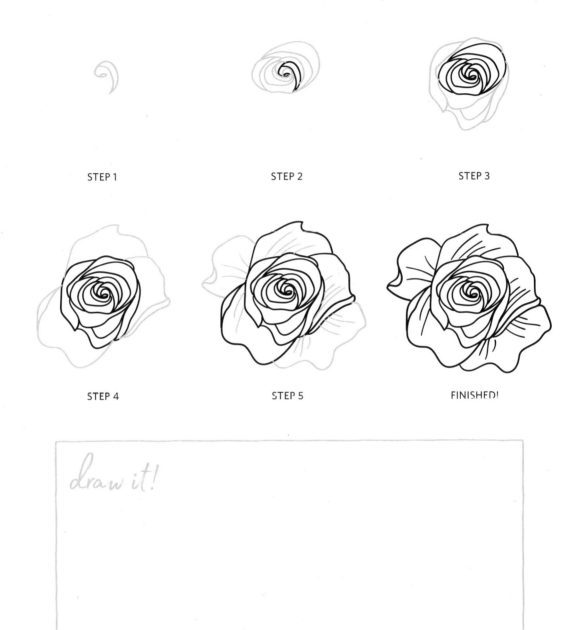

STEP 1

STEP 2

STEP 3

STEP 4

STEP 5

FINISHED!

draw it!

queen protea

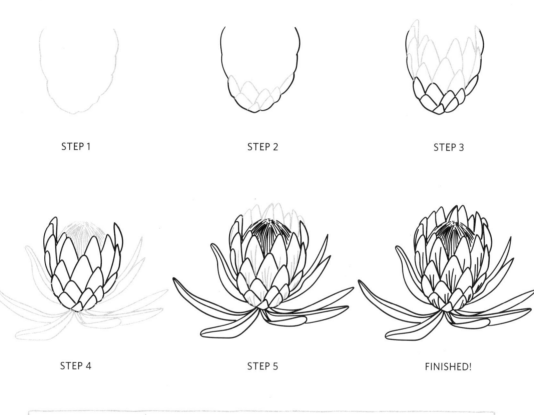

STEP 1 STEP 2 STEP 3

STEP 4 STEP 5 FINISHED!

draw it!

poppy

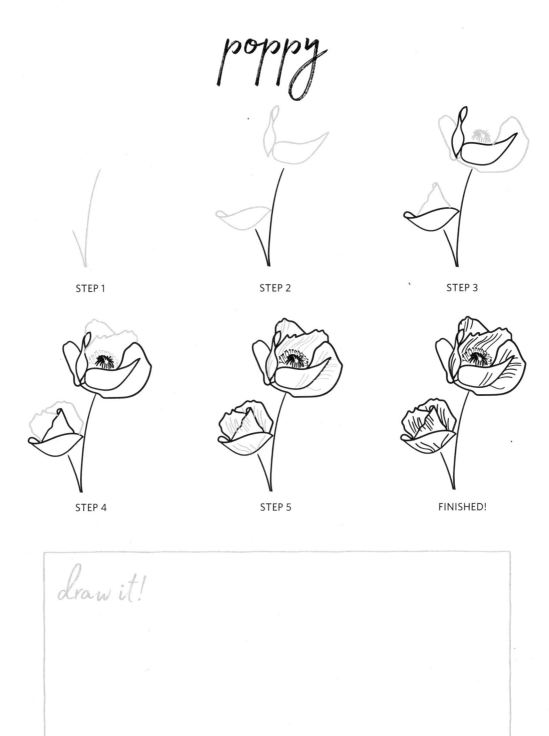

STEP 1

STEP 2

STEP 3

STEP 4

STEP 5

FINISHED!

draw it!

camellia

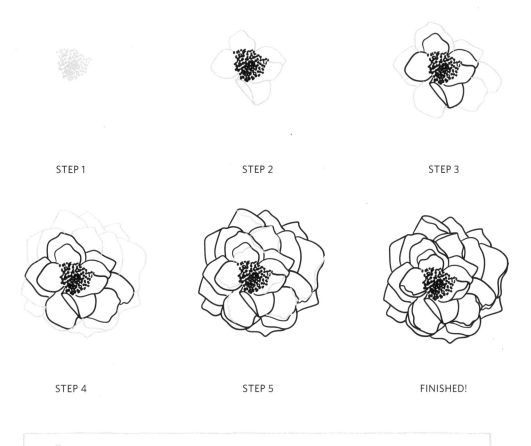

STEP 1

STEP 2

STEP 3

STEP 4

STEP 5

FINISHED!

draw it!

clematis

STEP 1

STEP 2

STEP 3

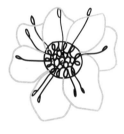

STEP 4

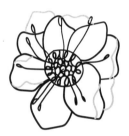

STEP 5

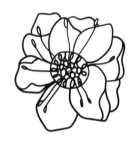

FINISHED!

draw it!

bell heather

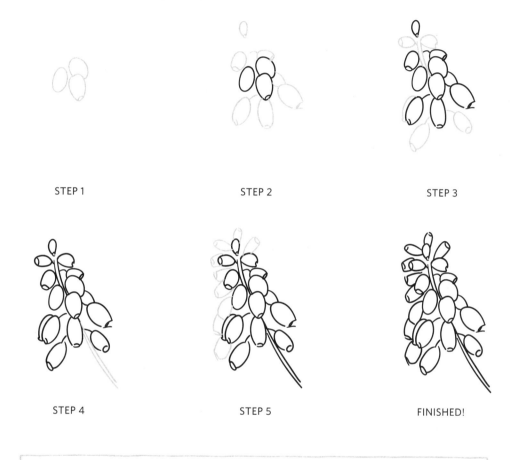

STEP 1

STEP 2

STEP 3

STEP 4

STEP 5

FINISHED!

draw it!

geranium

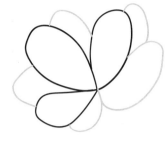

STEP 1

STEP 2

STEP 3

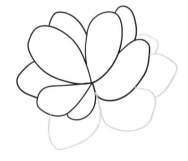
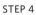

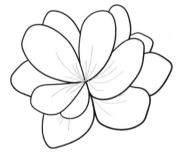

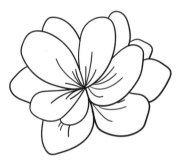

STEP 4

STEP 5

FINISHED!

draw it!

Pierre de Ronsard rose

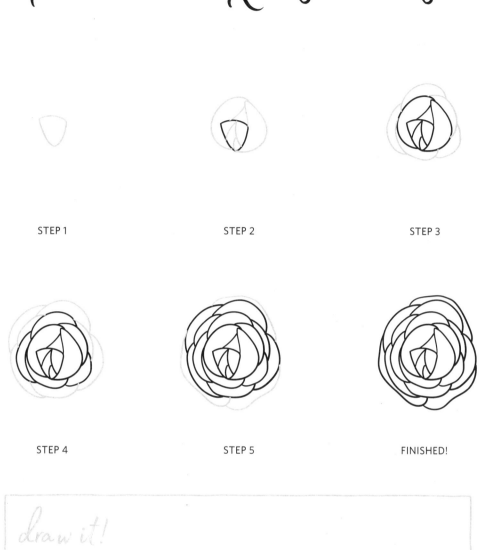

STEP 1

STEP 2

STEP 3

STEP 4

STEP 5

FINISHED!

draw it!

pansy

STEP 1 STEP 2 STEP 3

STEP 4 STEP 5 FINISHED!

draw it!

poppy

STEP 1

STEP 2

STEP 3

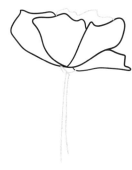

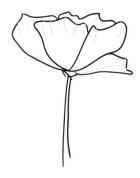

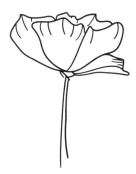

STEP 4

STEP 5

FINISHED!

draw it!

gloxinia

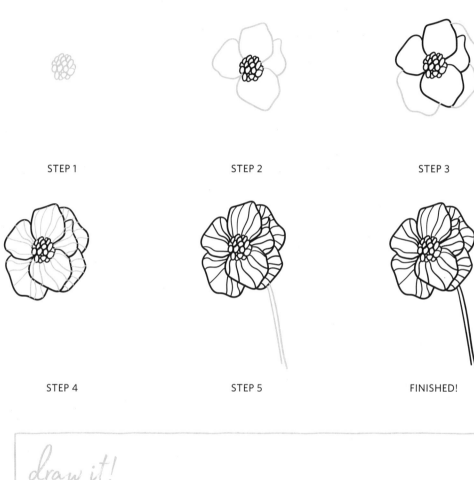

STEP 1

STEP 2

STEP 3

STEP 4

STEP 5

FINISHED!

draw it!

anemone

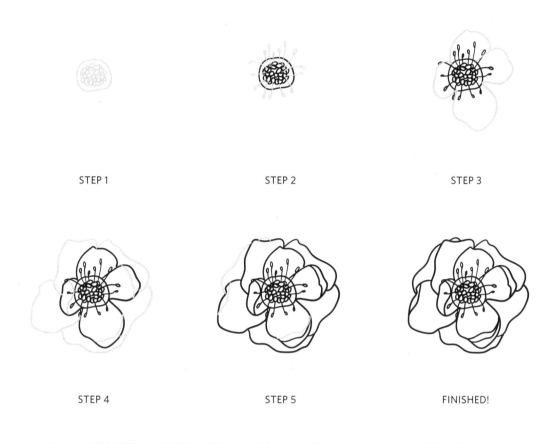

STEP 1

STEP 2

STEP 3

STEP 4

STEP 5

FINISHED!

draw it!

zinnia

STEP 1

STEP 2

STEP 3

STEP 4

STEP 5

FINISHED!

draw it!

cherry blossom

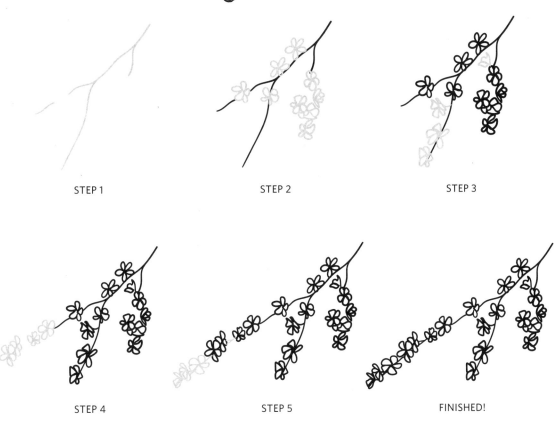

STEP 1

STEP 2

STEP 3

STEP 4

STEP 5

FINISHED!

draw it!

evening primrose

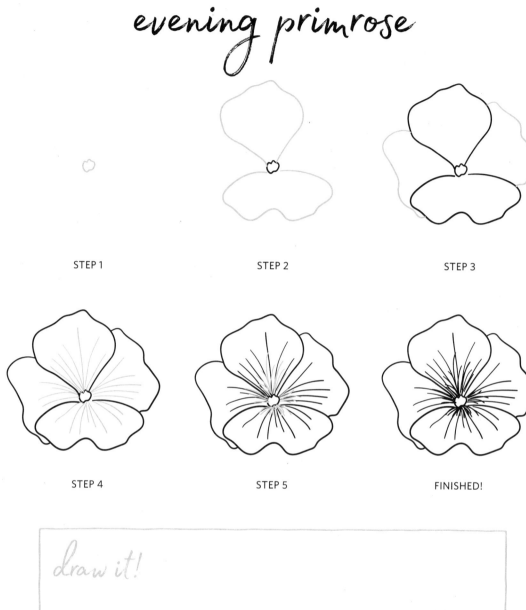

STEP 1

STEP 2

STEP 3

STEP 4

STEP 5

FINISHED!

draw it!

apple blossom camellia

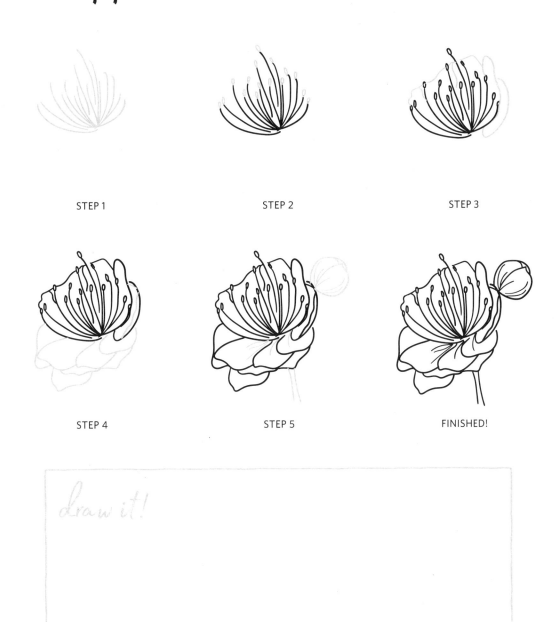

STEP 1

STEP 2

STEP 3

STEP 4

STEP 5

FINISHED!

draw it!

orchid

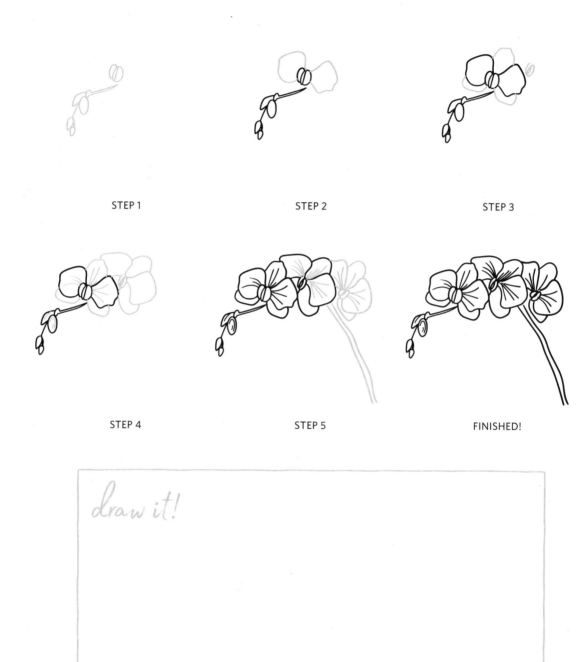

STEP 1

STEP 2

STEP 3

STEP 4

STEP 5

FINISHED!

draw it!

moonflower

STEP 1

STEP 2

STEP 3

STEP 4

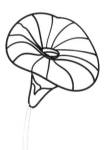

STEP 5

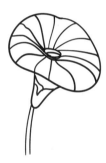

FINISHED!

draw it!

Queen Elizabeth rose

STEP 1

STEP 2

STEP 3

STEP 4

STEP 5

FINISHED!

draw it!

mullein

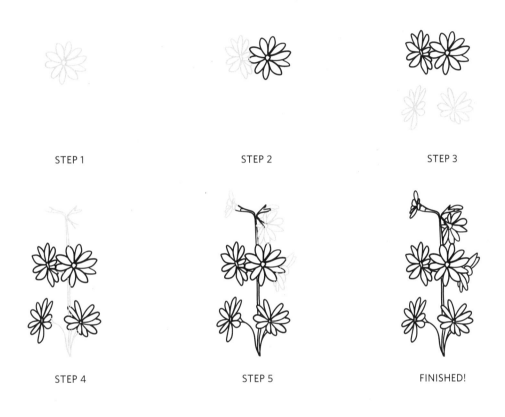

STEP 1

STEP 2

STEP 3

STEP 4

STEP 5

FINISHED!

draw it!

dandelion

STEP 1

STEP 2

STEP 3

STEP 4

STEP 5

FINISHED!

draw it!

peony

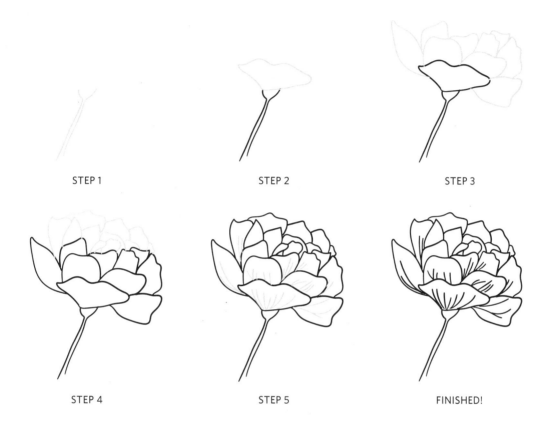

STEP 1

STEP 2

STEP 3

STEP 4

STEP 5

FINISHED!

draw it!

tweedia

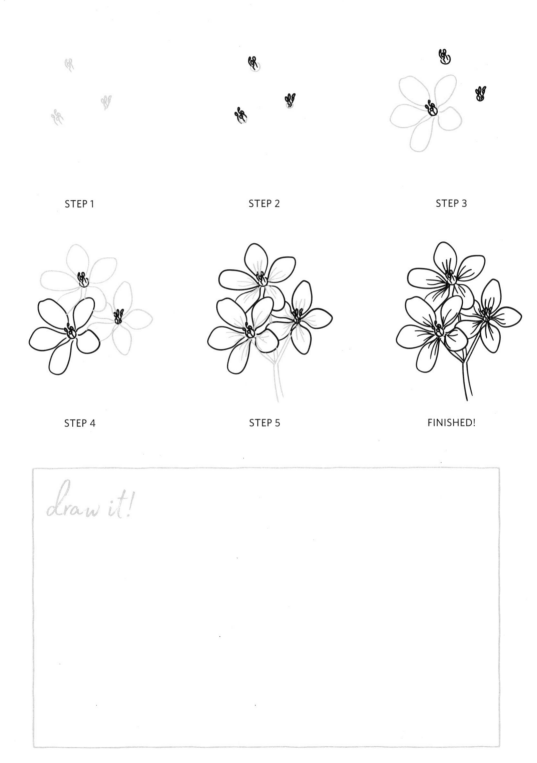

STEP 1

STEP 2

STEP 3

STEP 4

STEP 5

FINISHED!

draw it!

hollyhock

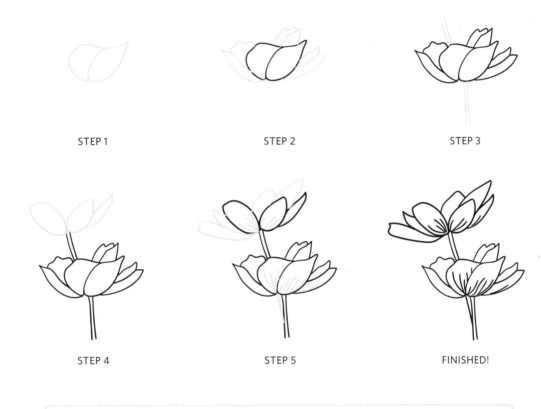

STEP 1

STEP 2

STEP 3

STEP 4

STEP 5

FINISHED!

draw it!

St. John's wort

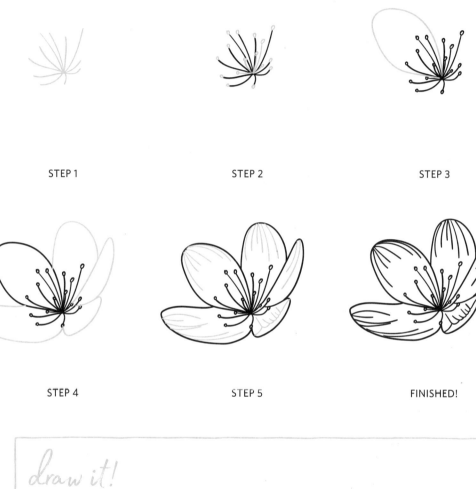

STEP 1

STEP 2

STEP 3

STEP 4

STEP 5

FINISHED!

draw it!

cactus dahlia

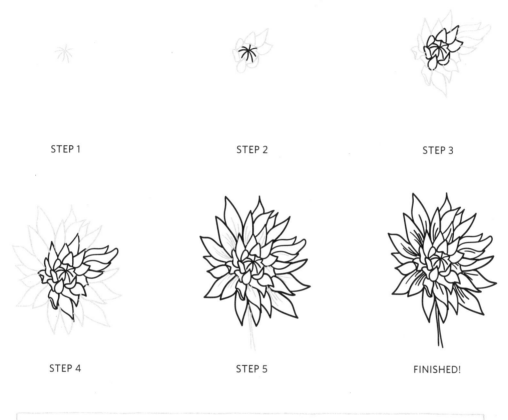

STEP 1

STEP 2

STEP 3

STEP 4

STEP 5

FINISHED!

draw it!

Canterbury bell

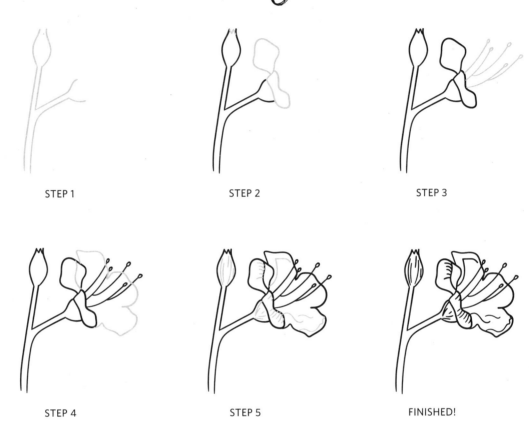

STEP 1

STEP 2

STEP 3

STEP 4

STEP 5

FINISHED!

draw it!

lotus

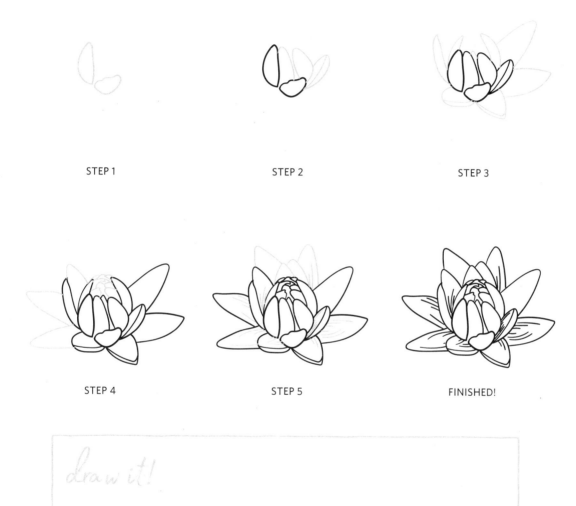

STEP 1

STEP 2

STEP 3

STEP 4

STEP 5

FINISHED!

draw it!

dwarf carnation

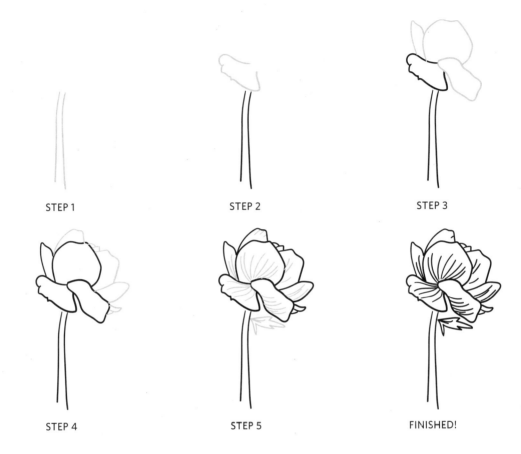

STEP 1

STEP 2

STEP 3

STEP 4

STEP 5

FINISHED!

draw it!

gerbera daisy

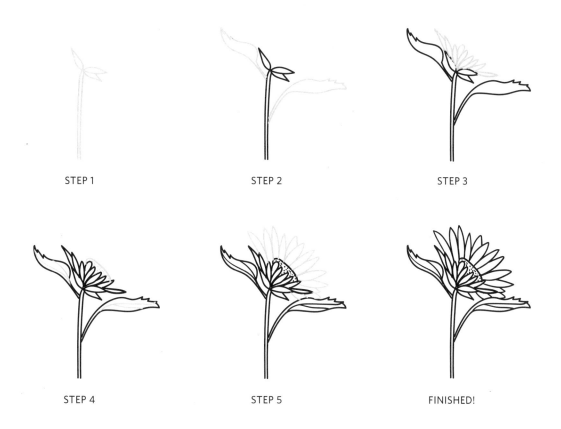

STEP 1

STEP 2

STEP 3

STEP 4

STEP 5

FINISHED!

draw it!

fairy primrose

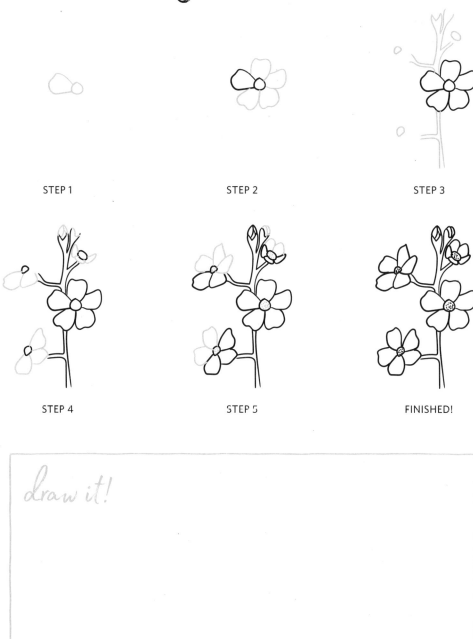

STEP 1

STEP 2

STEP 3

STEP 4

STEP 5

FINISHED!

draw it!

mountain balm

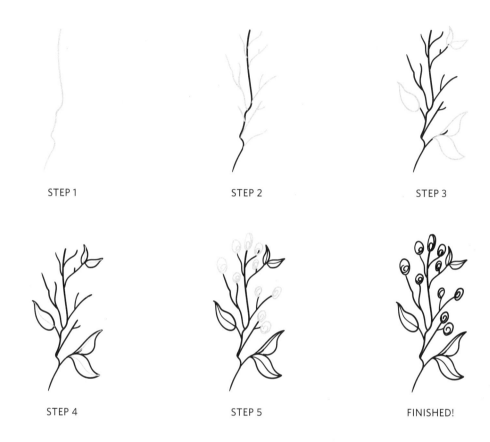

STEP 1

STEP 2

STEP 3

STEP 4

STEP 5

FINISHED!

draw it!

plumeria

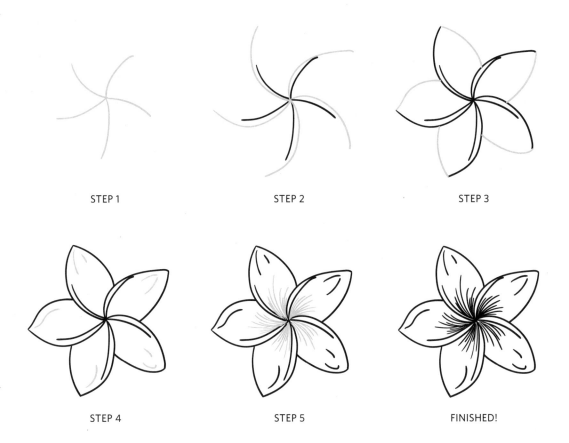

STEP 1 STEP 2 STEP 3

STEP 4 STEP 5 FINISHED!

draw it!

desert rose

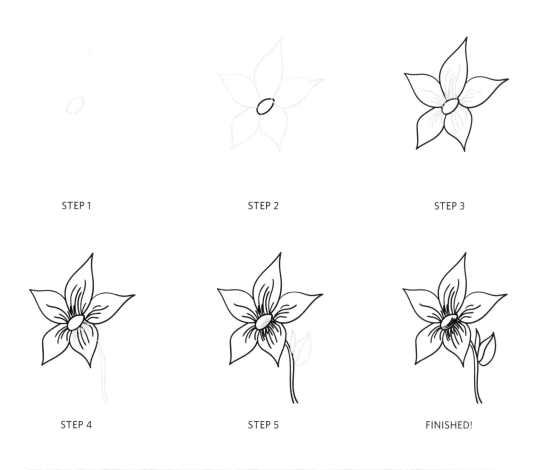

STEP 1 STEP 2 STEP 3

STEP 4 STEP 5 FINISHED!

draw it!

everlast lilac eye

STEP 1

STEP 2

STEP 3

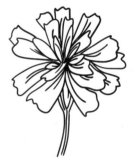

STEP 4

STEP 5

FINISHED!

draw it!

violet

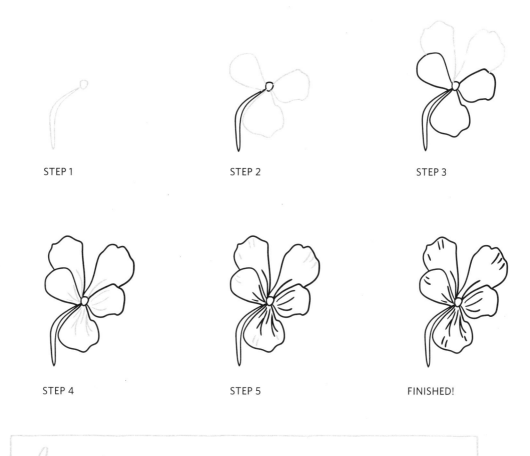

STEP 1

STEP 2

STEP 3

STEP 4

STEP 5

FINISHED!

draw it!

peony

STEP 1

STEP 2

STEP 3

STEP 4

STEP 5

FINISHED!

draw it!

Queen Anne's lace

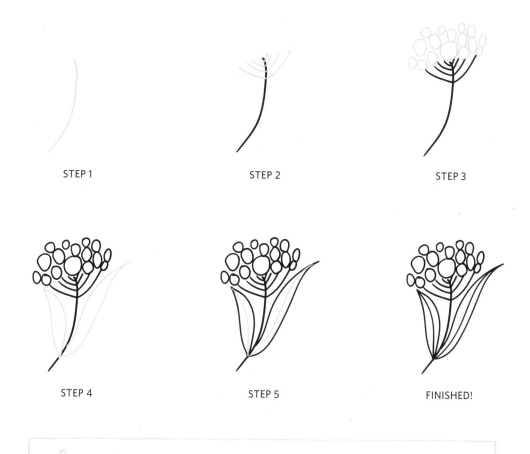

STEP 1

STEP 2

STEP 3

STEP 4

STEP 5

FINISHED!

draw it!

rosa

STEP 1

STEP 2

STEP 3

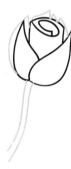

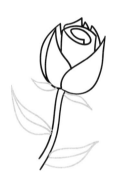

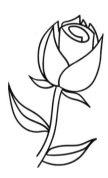

STEP 4

STEP 5

FINISHED!

draw it!

lily tulip

STEP 1

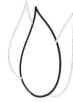

STEP 2

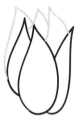

STEP 3

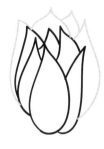

STEP 4

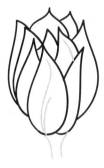

STEP 5

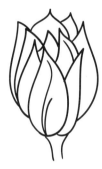

FINISHED!

draw it!

hyacinth

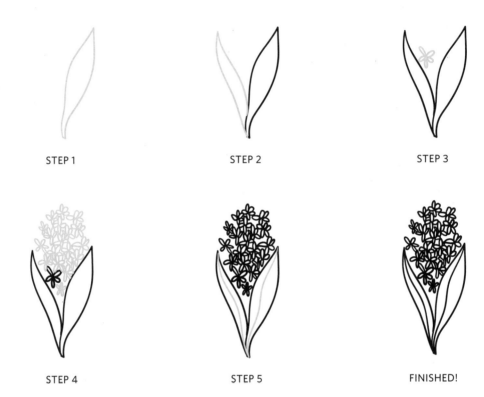

STEP 1 STEP 2 STEP 3

STEP 4 STEP 5 FINISHED!

draw it!

cup-and-saucer vine

STEP 1

STEP 2

STEP 3

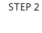

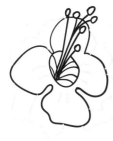

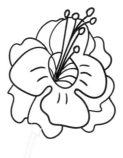

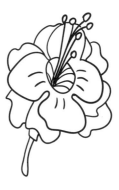

STEP 4

STEP 5

FINISHED!

baileya

STEP 1

STEP 2

STEP 3

STEP 4

STEP 5

FINISHED!

draw it!

African daisy

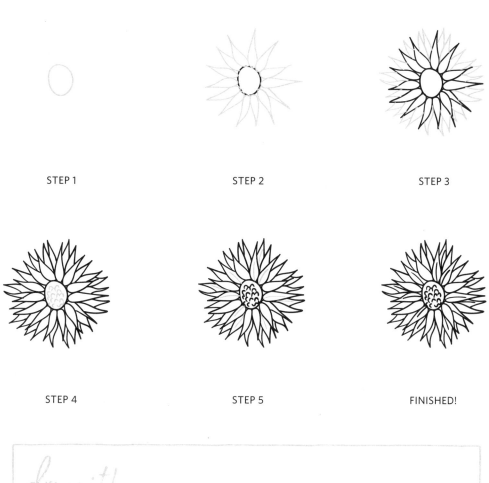

STEP 1 STEP 2 STEP 3

STEP 4 STEP 5 FINISHED!

draw it!

rudbeckia

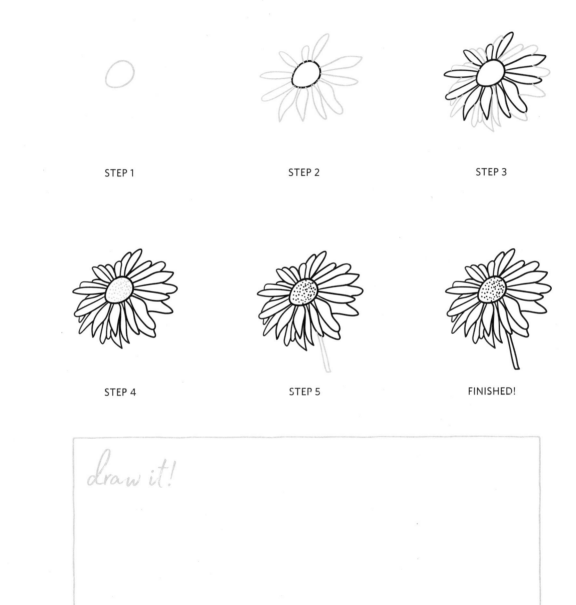

STEP 1

STEP 2

STEP 3

STEP 4

STEP 5

FINISHED!

draw it!

pink trumpet vine

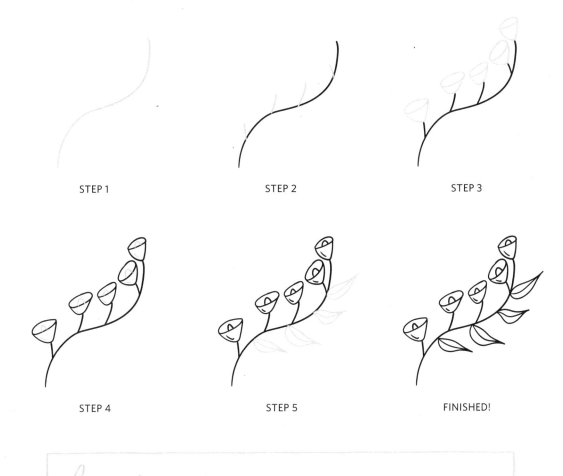

STEP 1

STEP 2

STEP 3

STEP 4

STEP 5

FINISHED!

draw it!

phlox

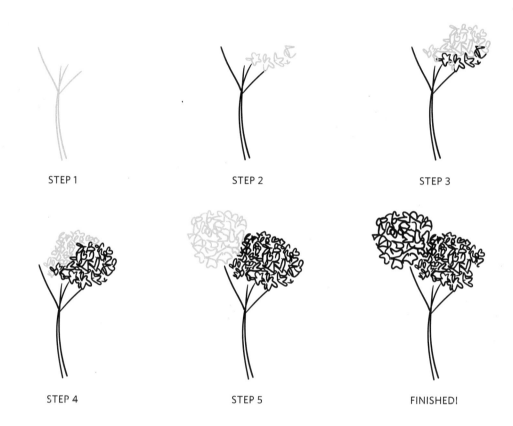

STEP 1

STEP 2

STEP 3

STEP 4

STEP 5

FINISHED!

draw it!

allium

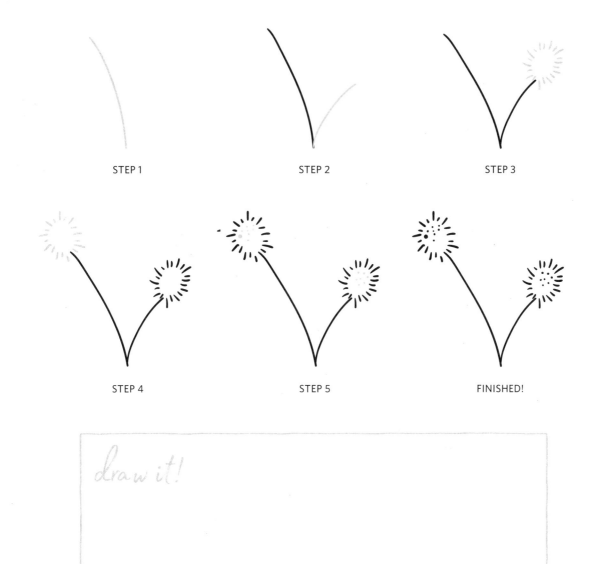

STEP 1

STEP 2

STEP 3

STEP 4

STEP 5

FINISHED!

draw it!

Cacti and Succulents

agave

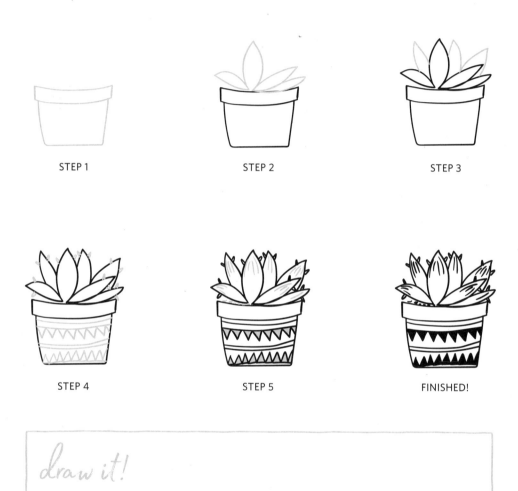

STEP 1

STEP 2

STEP 3

STEP 4

STEP 5

FINISHED!

draw it!

aloe vera

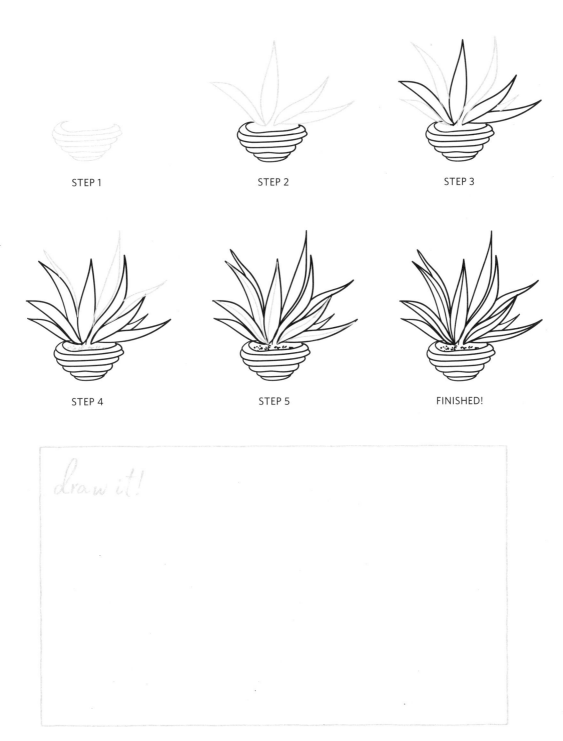

STEP 1

STEP 2

STEP 3

STEP 4

STEP 5

FINISHED!

draw it!

terrarium

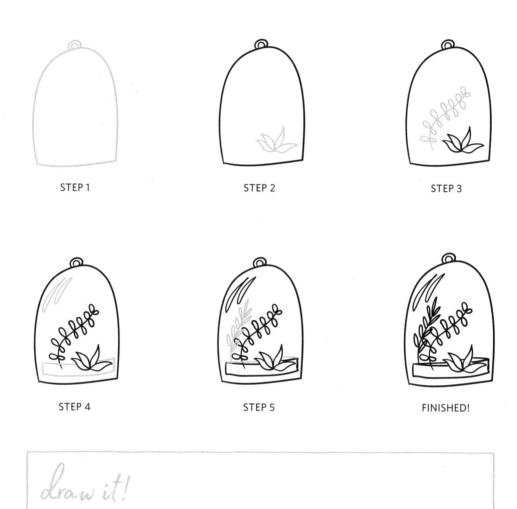

STEP 1

STEP 2

STEP 3

STEP 4

STEP 5

FINISHED!

draw it!

snow white cactus

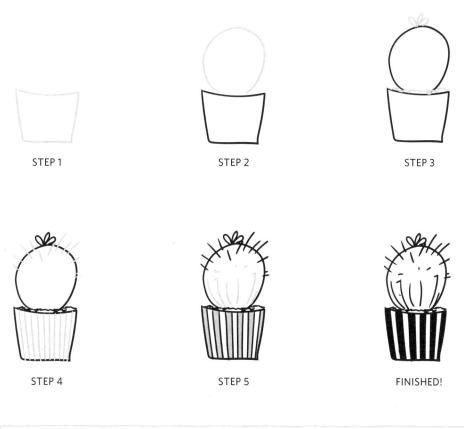

STEP 1

STEP 2

STEP 3

STEP 4

STEP 5

FINISHED!

draw it!

san pedro cactus

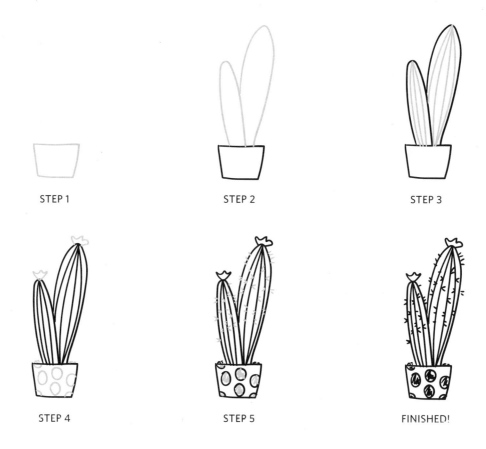

STEP 1

STEP 2

STEP 3

STEP 4

STEP 5

FINISHED!

draw it!

baseball cactus

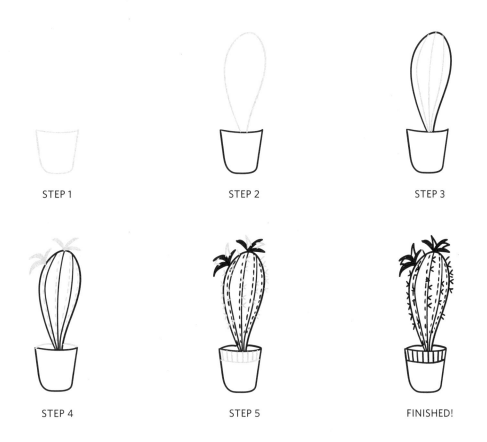

STEP 1

STEP 2

STEP 3

STEP 4

STEP 5

FINISHED!

draw it!

snake plant

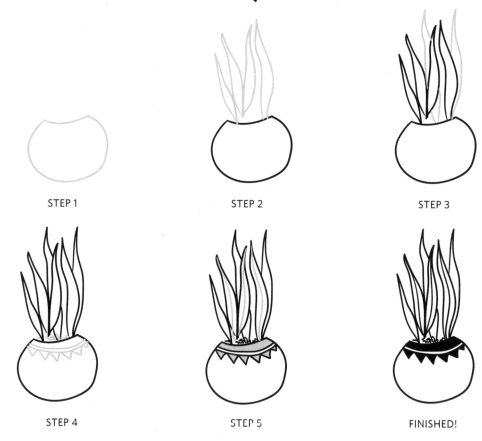

STEP 1

STEP 2

STEP 3

STEP 4

STEP 5

FINISHED!

draw it!

red cap cactus

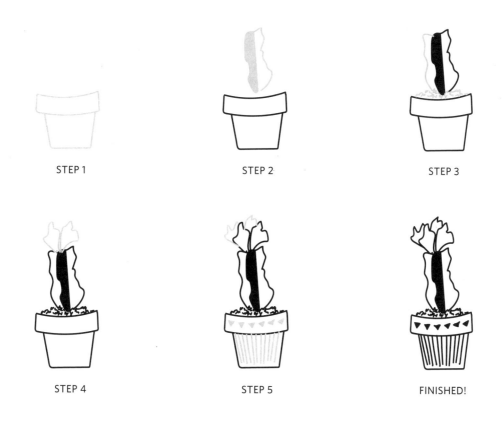

STEP 1

STEP 2

STEP 3

STEP 4

STEP 5

FINISHED!

draw it!

saguaro

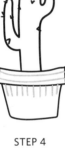

STEP 1

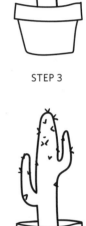

STEP 2

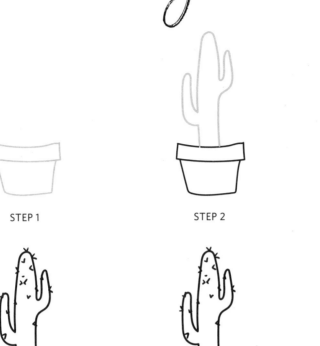

STEP 3

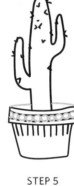

STEP 4

STEP 5

FINISHED!

draw it!

zebra cactus

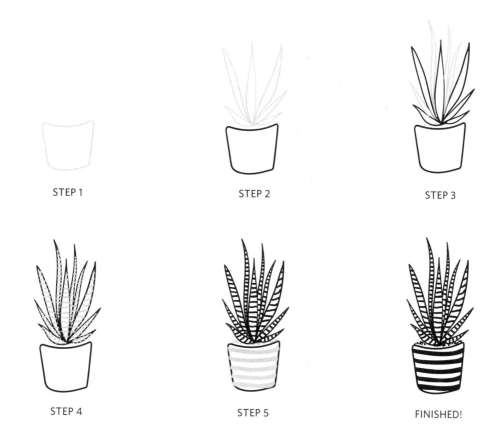

STEP 1

STEP 2

STEP 3

STEP 4

STEP 5

FINISHED!

draw it!

mixed arrangement

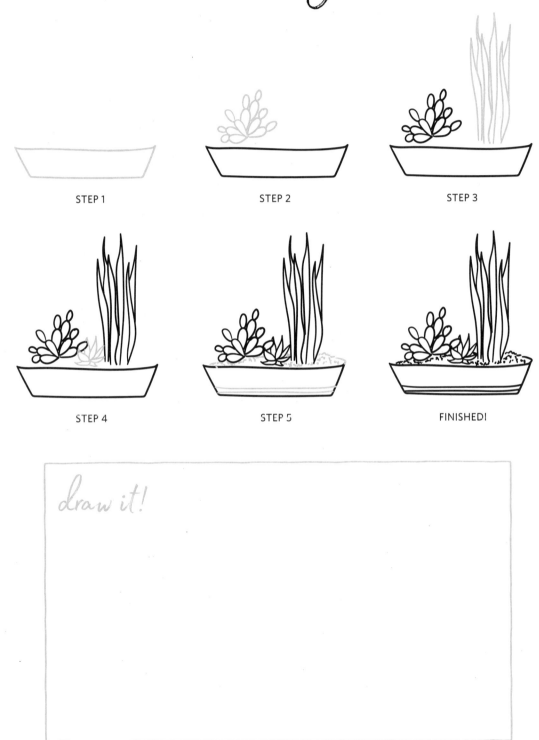

STEP 1

STEP 2

STEP 3

STEP 4

STEP 5

FINISHED!

draw it!

blue columnar cactus

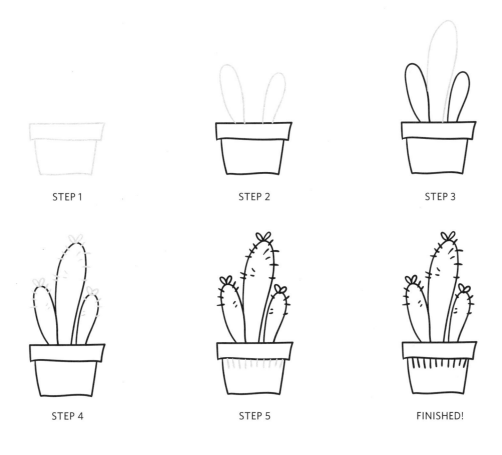

STEP 1

STEP 2

STEP 3

STEP 4

STEP 5

FINISHED!

draw it!

plaid cactus

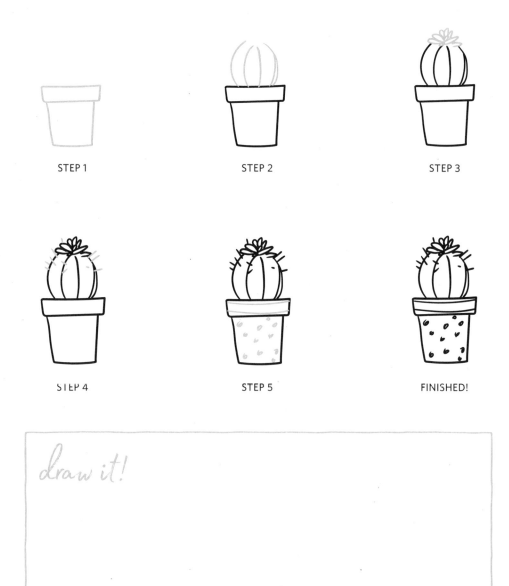

STEP 1

STEP 2

STEP 3

STEP 4

STEP 5

FINISHED!

draw it!

blueberry cactus

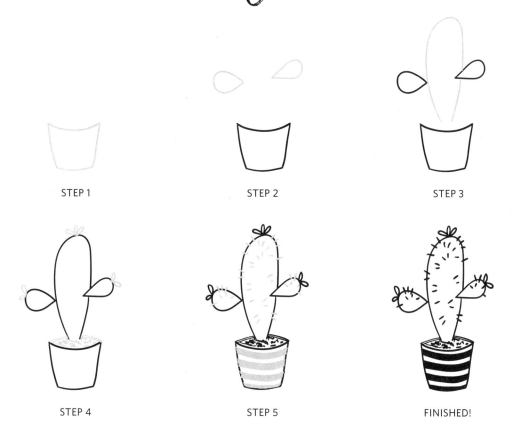

STEP 1 STEP 2 STEP 3

STEP 4 STEP 5 FINISHED!

draw it!

toothpick cactus

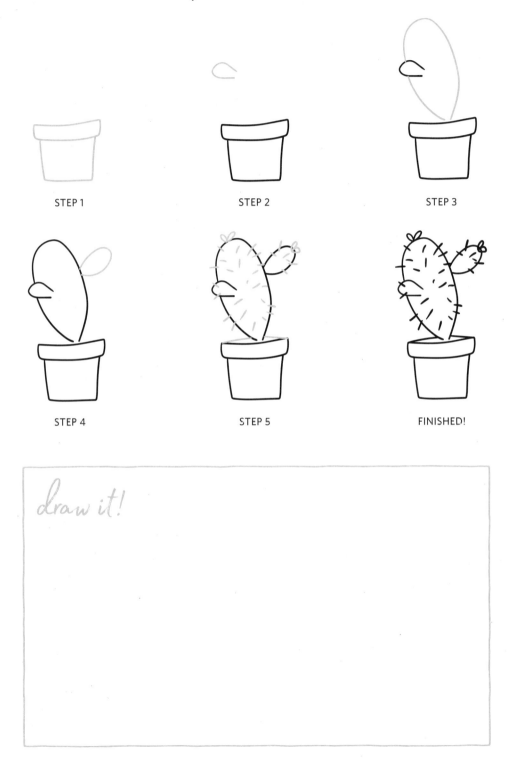

STEP 1

STEP 2

STEP 3

STEP 4

STEP 5

FINISHED!

draw it!

cactus spurge

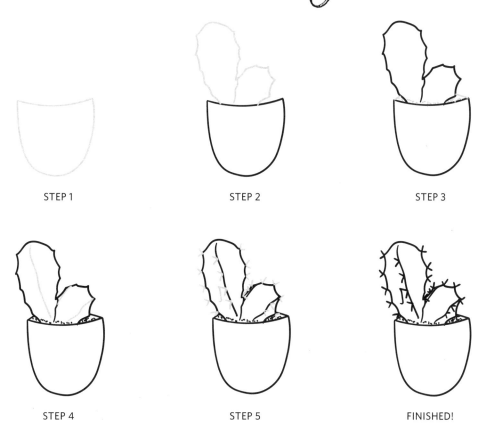

STEP 1 STEP 2 STEP 3

STEP 4 STEP 5 FINISHED!

draw it!

More
Nature

cotton

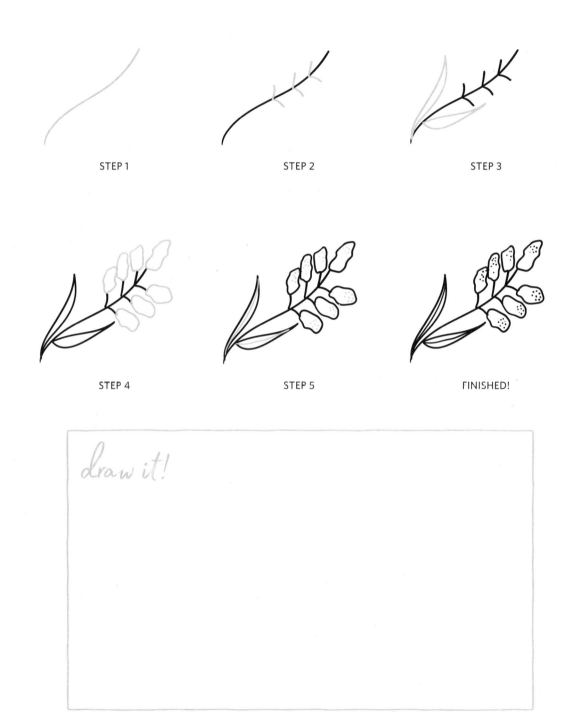

STEP 1

STEP 2

STEP 3

STEP 4

STEP 5

FINISHED!

draw it!

silvergrass

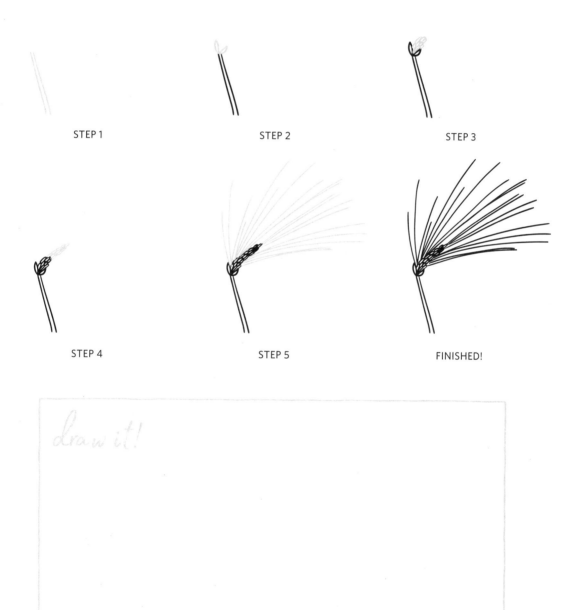

STEP 1

STEP 2

STEP 3

STEP 4

STEP 5

FINISHED!

draw it!

wheat

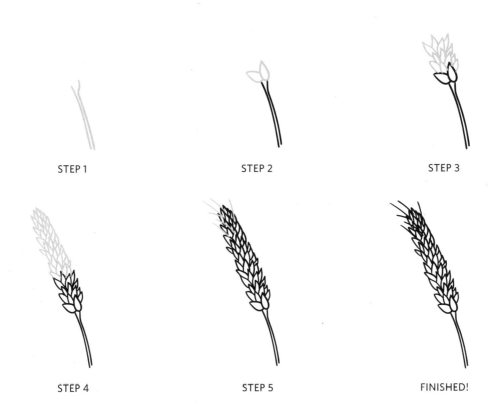

STEP 1

STEP 2

STEP 3

STEP 4

STEP 5

FINISHED!

draw it!

fly agaric

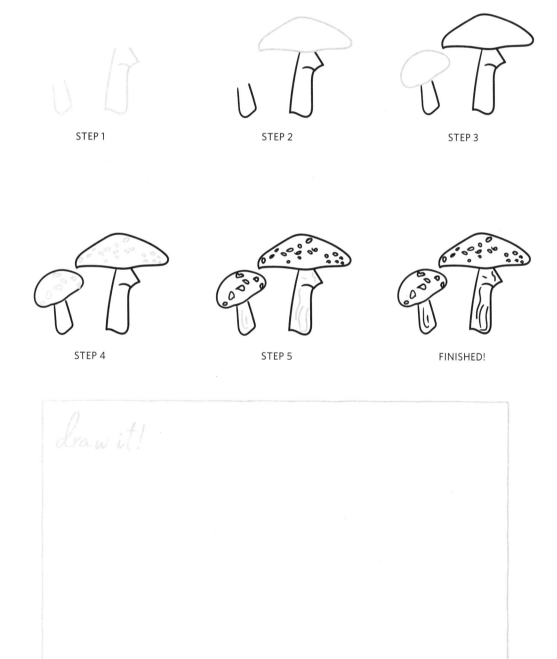

STEP 1

STEP 2

STEP 3

STEP 4

STEP 5

FINISHED!

draw it!

wild parsnip

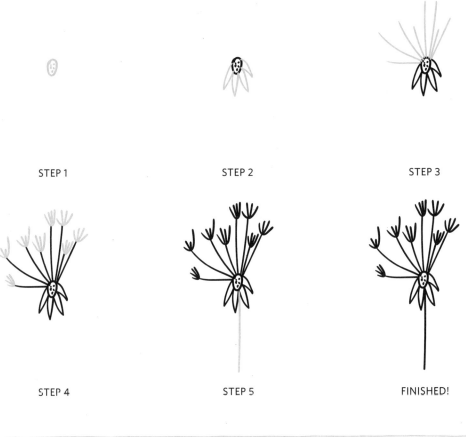

STEP 1

STEP 2

STEP 3

STEP 4

STEP 5

FINISHED!

draw it!

wrinkled peach mushroom

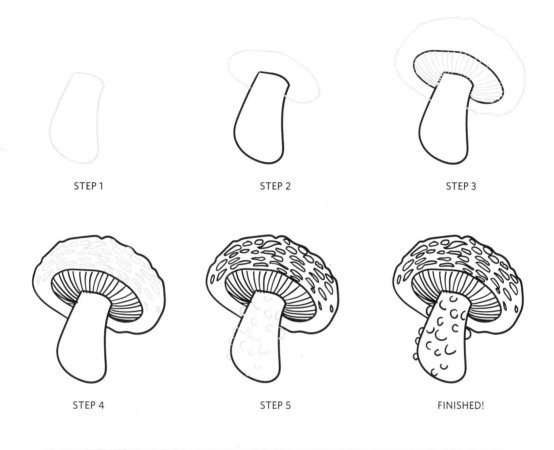

STEP 1

STEP 2

STEP 3

STEP 4

STEP 5

FINISHED!

draw it!

feather

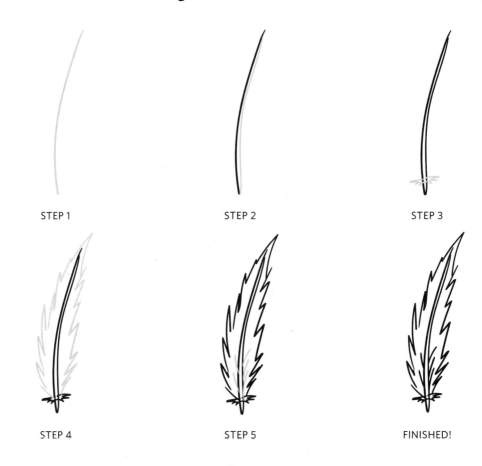

STEP 1

STEP 2

STEP 3

STEP 4

STEP 5

FINISHED!

draw it!

wreath

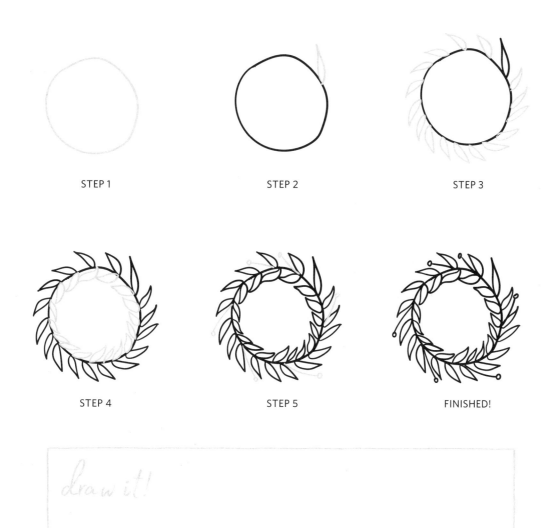

STEP 1

STEP 2

STEP 3

STEP 4

STEP 5

FINISHED!

draw it!

twig

STEP 1

STEP 2

STEP 3

STEP 4

STEP 5

FINISHED!

draw it!

blackberry

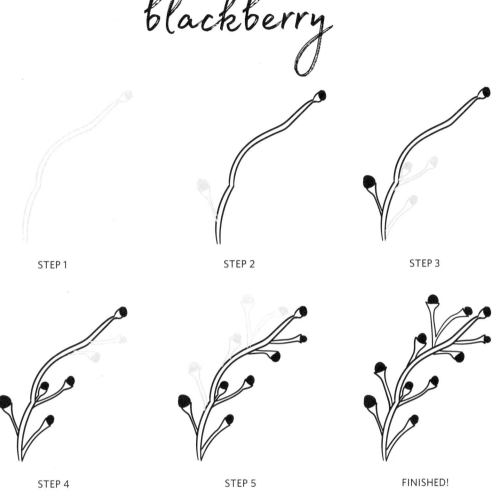

STEP 1

STEP 2

STEP 3

STEP 4

STEP 5

FINISHED!

draw it!

eastern hemlock cone

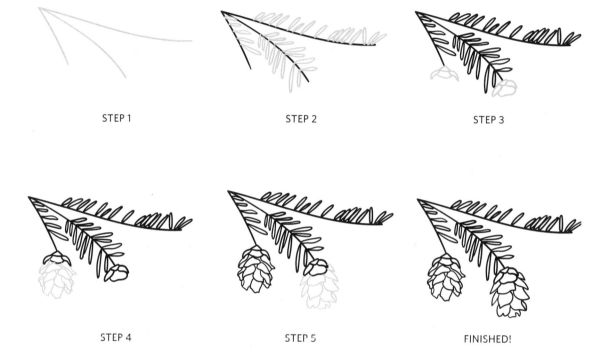

STEP 1

STEP 2

STEP 3

STEP 4

STEP 5

FINISHED!

draw it!

acorn

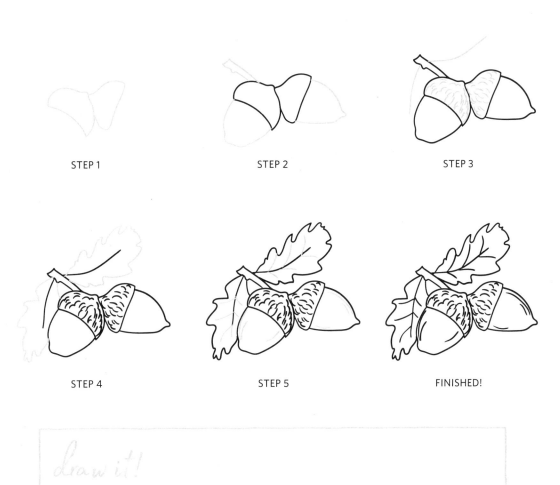

STEP 1 STEP 2 STEP 3

STEP 4 STEP 5 FINISHED!

draw it!

amanita

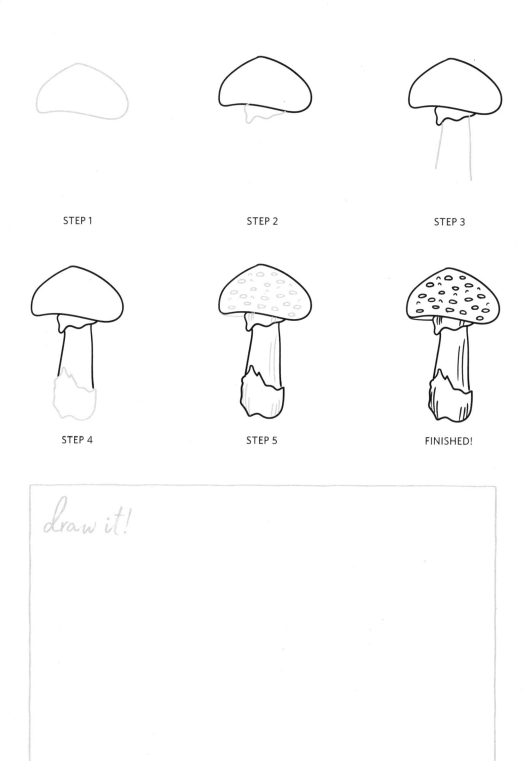

STEP 1

STEP 2

STEP 3

STEP 4

STEP 5

FINISHED!

draw it!

tree ring

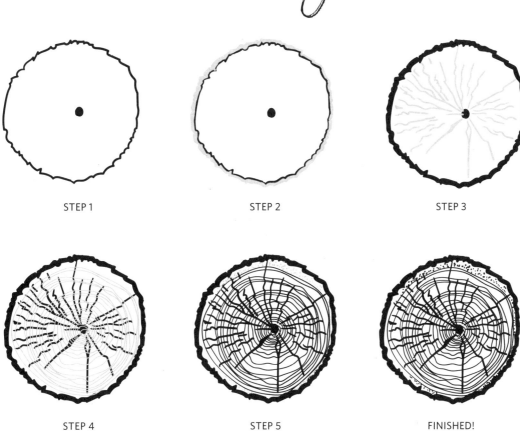

STEP 1

STEP 2

STEP 3

STEP 4

STEP 5

FINISHED!

draw it!

dandelion

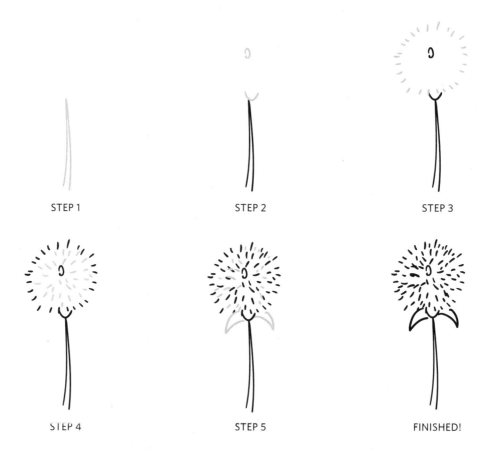

STEP 1 STEP 2 STEP 3

STEP 4 STEP 5 FINISHED!

draw it!

poppy seed head

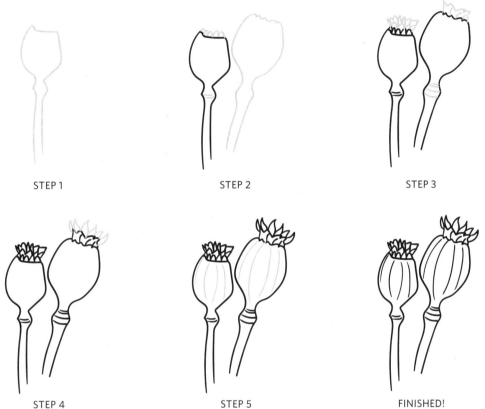

STEP 1

STEP 2

STEP 3

STEP 4

STEP 5

FINISHED!

draw it!

holly

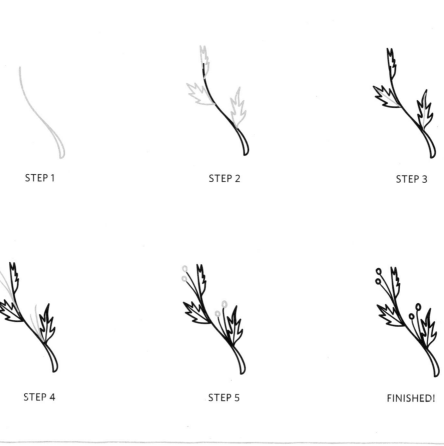

STEP 1

STEP 2

STEP 3

STEP 4

STEP 5

FINISHED!

draw it!

angelica

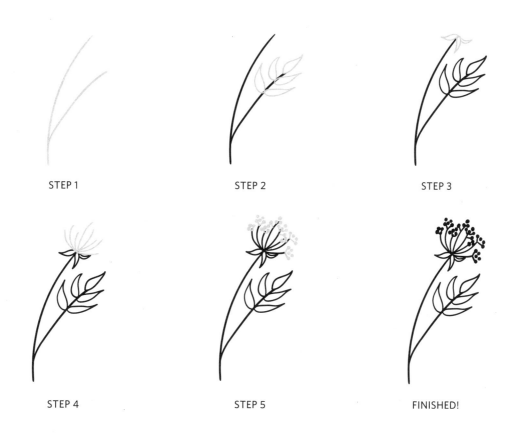

STEP 1

STEP 2

STEP 3

STEP 4

STEP 5

FINISHED!

draw it!

veronia

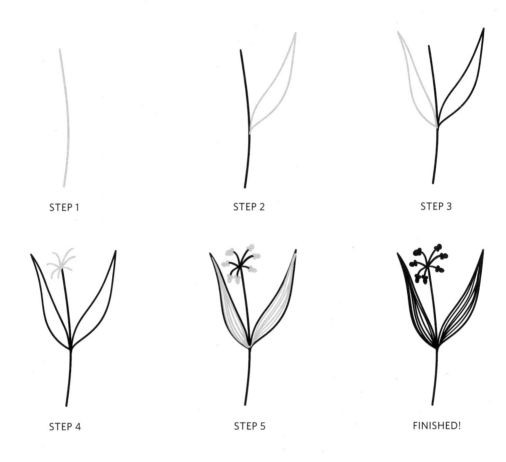

STEP 1

STEP 2

STEP 3

STEP 4

STEP 5

FINISHED!

draw it!

wild fennel

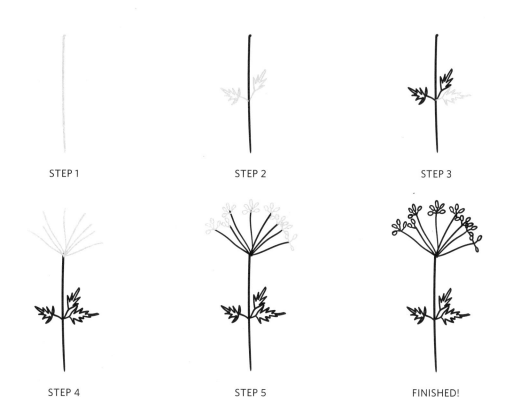

STEP 1

STEP 2

STEP 3

STEP 4

STEP 5

FINISHED!

draw it!

white lace flower

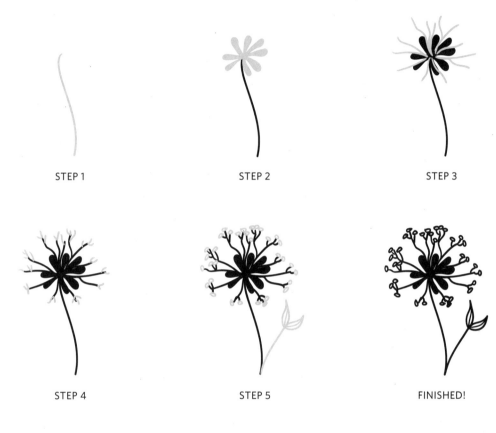

STEP 1

STEP 2

STEP 3

STEP 4

STEP 5

FINISHED!

draw it!

wild carrot

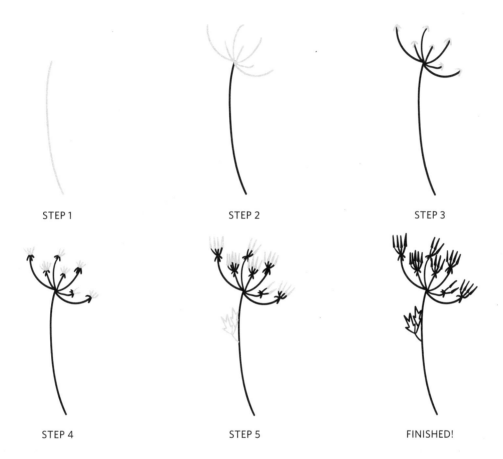

STEP 1

STEP 2

STEP 3

STEP 4

STEP 5

FINISHED!

draw it!

seeding dandelion

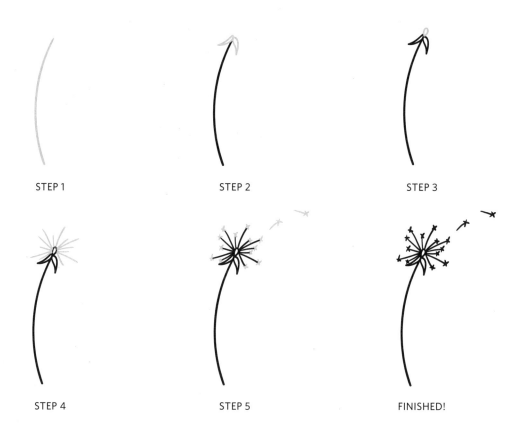

STEP 1

STEP 2

STEP 3

STEP 4

STEP 5

FINISHED!

draw it!

common field mushroom

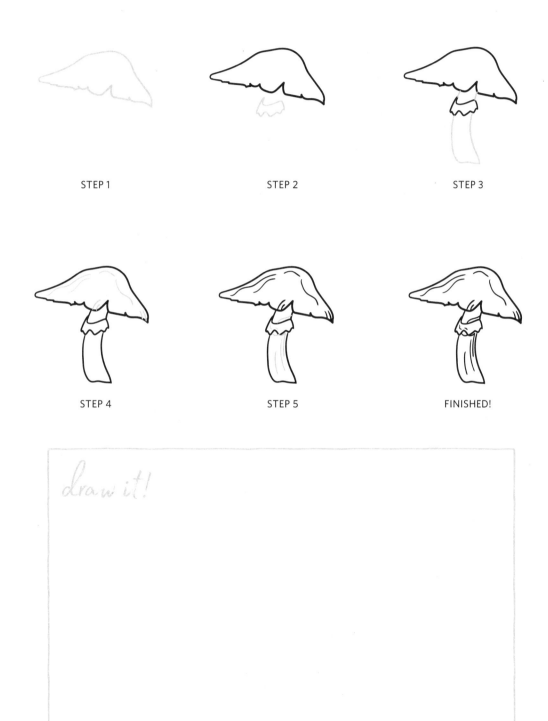

STEP 1

STEP 2

STEP 3

STEP 4

STEP 5

FINISHED!

draw it!

Resources

Although botanical line drawing doesn't take special tools, you may still wonder about some of the best material options. This is a quick guide for you!

PENS

If you plan on including any watermedia (watercolors) with your illustration, you want to make sure that the ink you use doesn't bleed. It wouldn't matter much if you were drawing over watercolor, but often times, folks draw their flowers and then go back to add color. There are some permanent archival pens out there that will help you achieve this. They are fast drying and don't react to water.

The first I'll mention is the well-known Micron pen. This pen comes in a large variety of tip sizes so you can grab what suits your fancy. The lower the number, the smaller the tip.

The Pigeon Letters has a line of permanent archival pens called Monoline Studio. These are similar to Microns and come in sizes 01, 03, and 05. They also have a little window in the cap that lets you see the tip!

If you're not worried about archival-quality pens, anything will do—and I mean anything! Grab a ballpoint pen, a felt marker, a pencil, even a random crayon! The idea is to get to drawing. Doodle anytime, anywhere.

PAPER

Paper is another consideration if you're using watermedia with your illustrations. Stick to mixed media (usually 98lb) or watercolor paper (140lb or higher). These papers are built to withstand water.

If you're just looking to draw, there are a variety of drawing papers you might see (oftentimes, these are targeted toward fine artists who draw with graphite and charcoal, so it's not made for line drawing but works great). For practicing, I love Rhodia pads. They come in many sizes and even have guides if you want them, although I opt for the blank pads. This paper is pretty thin, though, so if you're going for something more finished, look for Bristol paper. It's a nice, thick paper with a smooth finish.

That's it! I advise you to simply start with what you have—a napkin and crayon will do. Okay, it's not ideal, but you get the idea. Happy drawing!

the blog

WWW.THEPIGEONLETTERS.COM

Discover additional tips, DIY projects, art supplies,
original artwork, online watch-at-your-leisure classes,
and a plethora of inspiration by visiting

Let's See Your Work!
#botanicallinedrawing

Acknowledgments

The amount of love and support I've received from so many creatives has opened the door for my little passion project to blossom (pun intended) into print. Inspiration is everywhere, and I can't thank this community enough for letting me share your journey with you. Thank you to my amazing wife and family for letting me live a creative, unstructured life so I could bloom (another pun intended) into an artist. Thank you to God, Mother Nature, science, whatever you believe in, for putting such beauty on this earth that we can see, smell, touch, taste, and hear every day. What a beautiful, beautiful world. To my agent Carrie Howland (and Andy Barzvi), thank you for pushing me to my highest potential and not letting me stand in my own way. Thank you to my team at Ten Speed Press for their passion in exposing this project to more of the world, and to Tyler Spencer for some phenomenal design edits. Without you guys—well, you know.

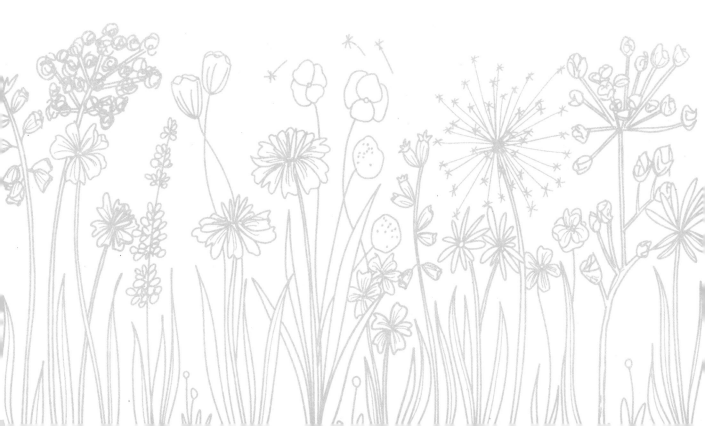

About the Author

Peggy is a self-taught artist who is proud to offer a non-conventional method of accessible education to anyone who wants to thrive in the art scene. She believes that more than anything art is about empowering oneself and being proud of something you've created with your hands. She is an award-winning educator, and her unique approach has landed her an interview on the *Today Show*, amongst several other news outlets. Living her passion has allowed her to spend more time with her family in the Pacific Northwest, surrounded by the most beautiful nature in the world.

Published in the United States by Watson-Guptill
Publications, an imprint of the Crown Publishing Group,
a division of Penguin Random House LLC, New York.
www.crownpublishing.com
www.watsonguptill.com

WATSON-GUPTILL and the HORSE HEAD colophon are
registered trademarks of Penguin Random House LLC.

Library of Congress control number 2018936791.

Trade Paperback ISBN: 978-0-399-58219-6
eBook ISBN: 978-0-399-58220-2

Printed in the United States of America

Design by Debbie Berne

10 9 8 7 6 5 4 3 2 1

First Watson-Guptill Edition